SECRET SHEPPERTON
ENGLAND'S HOLLYWOOD

Jill Armitage

AMBERLEY

*Dedicated to Bree, without whom I would never have discovered
all the secret places of Shepperton*

First published 2022

Amberley Publishing
The Hill, Stroud
Gloucestershire, GL5 4EP

www.amberley-books.com

Copyright © Jill Armitage, 2022

The right of Jill Armitage to be identified as the
Author of this work has been asserted in accordance
with the Copyrights, Designs and Patents Act 1988.

ISBN 978 1 3981 0716 8 (print)
ISBN 978 1 3981 0717 5 (ebook)

British Library Cataloguing in Publication Data.
A catalogue record for this book is available from the
British Library.

Origination by Amberley Publishing.
Printed in Great Britain.

Contents

Introduction

One of my first experiences after moving to the village of Shepperton was walking into a charity shop and finding the most weird and wonderful things. 'Most will go to the film studio,' explained the helpful assistant. 'They are always in here looking for unusual and period pieces for their props department.' As I mused through the rails I wondered if those dungarees worn by Meryl Streep in the film *Mama Mia* came off the £1 rail, or if that speaking bowl in the *Return of Mary Poppins* once sat on the battered bureau.

I thought my eyes were deceiving me when I saw a couple of colourful parakeets sitting on a bush in my garden. But no, apparently when they'd finished filming *Out of Africa* at the studios, the exotic birds were released and have since propagated on a grand scale.

Secret Shepperton explores the history of the town from its early origins as an Iron Age settlement nestling on the banks of the River Thames, which is where they discovered the best-preserved skeleton ever found while excavating Shepperton's Stone Henge. 'She' is now dubbed the world's oldest Londoner and is worthy of her place at the Museum of London. Shepperton is arguably the place where Caesar crossed the river in 54 BC. Subsequent river finds reveal that this area regularly encountered invaders, such as the Saxons, who grazed sheep here and consequently called it Shepperton. It's always been a place that attracts artists, such as Turner and Constable, and writers such as Charles Dickens and J. G. Ballard, who wrote the *Unlimited Dream Factory* in which his protagonist gains energy by phagocytizing the people of Shepperton. In H. G. Wells' *War of the Worlds*, the Martians destroy Shepperton and turn the Thames into a boiling inferno with their heat rays.

In the twentieth century Shepperton was dubbed the playground of London and Richard D'Oyly Carte bought an island here to build a mini version of his world-renowned Savoy Hotel. In 1931, Sir Richard Burbridge, chairman of Harrods, sold his Shepperton mansion to Norman Loudon at a time when 'the pictures' were in their infancy but a new fad was catching on – films with sound. This was the forerunner of Shepperton Studio, still operating today and known throughout the world as the 'Hollywood of England'.

1. Prehistory to Present Day

The Shepperton Stone Henge and the Oldest Londoner

Shepperton's story can be traced back over 5,500 years to the Bronze and Iron Age because in 1989, during gravel excavations at Staines Road Farm, Shepperton Green, traces of a Neolithic ringwork, an oval ditched enclosure known as a Henge (the best known being Stonehenge, Amesbury, Wiltshire) was discovered. This rare find would have acted as a tribal foci for the native Celts, yet historians and archaeologists still don't fully understand the significance of these great stones of mystery that could weigh as much as 26 tons each and were quarried by being cracked with stakes, fire, water and flint hammers. How and why they were hauled into their upright positions just adds to the mystery. They could have been observatories, used to mark the appearance of the sun at midsummer or midwinter, or to track the movement of the stars proving that these early people had advanced technology and a knowledge of astronomy.

The ring of the Shepperton Henge measured around 23 m (75.5 ft) in diameter and the entrance would have been at the end of a ceremonial route facing the midsummer sunrise. Preserved inside the circle of the henge were a number of finds including flint tools, antler picks, pottery, red ochre (used for ceremonial painting) and six red deer antlers believed to be of ritual significance. Many early gods were depicted with antlers, so the tribe elders would wear antler headdresses during religious rituals or dances, in tribute to their gods. Whether with stag antlers, the horns of a bull or ram, fertility and strength are implied, and later tribal warriors evoked the strength of the horned god by fashioning helmets with horns attached.

Henges would have been sacred places where religious rituals were carried out, and they may also have been for burying the dead as little is known of the burial customs of the Bronze and Iron Age. Very few skeletons have been excavated so it's possible that most bodies were cremated and their ashes scattered, or were left to rot in the open air (excarnation). The few burials that have survived are of great significance and nowhere is that more so than at Shepperton where among the Neolithic finds were human bones including an inhumation dating to roughly 5,500 years ago.

According to art historians at the Museum of London, they've got a few earlier bodies and human remains, but nothing quite as complete, making this inhumation very special. Pieces of the female skull were taken to Manchester University where they were carefully put together by dental pathologist Dr Caroline Wilkinson. Although 'she' has been dubbed London's first lady or the oldest Londoner, it's now believed from tests on lead levels in the skull's teeth that the Shepperton woman is not a from Shepperton at all. It's very likely that she came from Derbyshire, some 150 miles away.

DID YOU KNOW?
Dr Caroline Wilkinson made a bust of the 5,500-year-old inhumation found at
Shepperton Henge. Rebuilding the skull, then using clay and a mixture of scientific
and artistic skills, she was able to realistically reconstruct a bust that is now one of
the star attractions at the Museum of London.

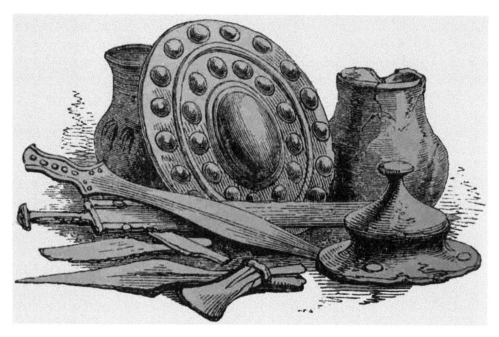

This engraving from an 1859 woodcut shows Iron Age items dredged from the Thames
around Shepperton.

Iron Age Finds and Roman Invasion

In this part of the country where the River Thames has been the main, most practical
highway since creation, one of the most significant river finds was unearthed in October
1966 while dredging the river near Wheatley's Ait. An 'ait' or 'eyot' is a small river island
(see more later). This amazing first-century find buried in about 4 feet (1.2 m) of mud and
silt was an almost complete oak tree trunk canoe, 18 feet 4 inch (5.56 m) long and 2 feet 11
inches (88.9 cm) wide. It would have been cut and burnt to achieve the required size and
depth to carry four people.

Numerous implements and weapons including a polished celt, a Bronze Age axe head,
a rapier, a dirk and daggers dating from before 500 BC have been dredged from the bed
of the river. Do these finds indicate that fighting took place here on the riverbank or were
they thrown in as religious offerings to placate the gods or ask for their blessings? River

crossing places held special significance and offerings were often given to the gods in anticipation of a safe crossing.

Initially it was thought that the alluvial soil was too waterlogged to sustain a domestic community but when building Jessiman Terrace, beside the M3 at Shepperton Green, a pot containing 360 Iron Age coins dating from 50 BC–AD 50 were found with or near some Iron Age pottery, animal bones, and heat-crackled flints. This hoard would suggest domestic occupation and to support this assumption, there's a late Bronze Age burial ground of some significance at Littleton in the northern district of Shepperton.

Hoards have always fascinated historians who ask the obvious question, why did people bury their wealth. Understandably we can never be sure, but one answer here at Shepperton could be that these Iron Age people were being invaded and the coins were buried with the intention of retrieving them later when danger had passed. The history books confirm there was an invasion in 54 BC when the Roman general Julius Caesar came to claim Britain for Rome.

DID YOU KNOW?
When Julius Caesar came to conquer Britain in 54 BC he crossed the Thames at Shepperton, and evidence of his battle with the Catuvellauni tribe has been found at the riverside meadow now called War Close.

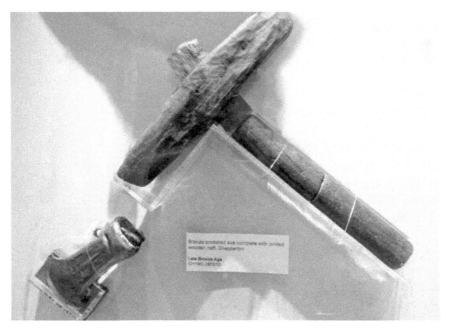

Late Bronze Age socketed stone axe, complete with jointed wooden haft, found at Shepperton. Now in Chertsey Museum.

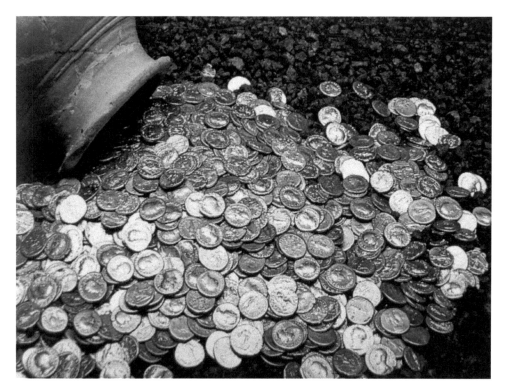

An Iron Age hoard of 360 coins was found at Shepperton Green.

Caesar landed in England accompanied by five legions and 2,000 cavalry, and fought his way towards the River Thames, which the Celts knew as Tamesis or Tamesa, and Caesar translated as Thamesis. Caesar's own report in *Commentaries on the Gallic Wars* states that 'The river was passable on foot only at one place and that with difficulty'. As Caesar didn't name a place (most names were not allocated until very much later), historian have been guessing ever since, and local legend claims that Caesar crossed the Thames here at Cowey Sales (previous known as Cowey Stakes) just upstream from the bridge linking Walton on the south bank, with Shepperton on the north bank.

Before efficient weirs and locks deepened the water, this area was renowned for its sandbanks and shallows so it would have been relatively easy to ford the river here. The Roman armies would have faced the Catuvellauni tribe who occupied this area at the time. The Romans referred to them as naked savages. They may have looked savage when they went to war, but they were not savages. They believed that if the gods decided that they should die fighting, no amount of armour would protect them, so they went into battle naked. They had faith that their protection lay in the intricate, magical designs that they covered their bodies with, a forerunner of our modern tattoos. Using a blue dye from the plant isatis tinctorial, better known as woad, which grew in profusion around the Shepperton riverbank, the body decoration not only imparted a ferocious aspect in battle, the Celts believed it would deflect enemy blows and missiles.

DID YOU KNOW?
The Romans referred to the ancient Britons as Picts, meaning painted or tattooed and from where we get the word 'picture'.

In Caesar's *Commentaries on the Gallic Wars*, he states 'the bank moreover was planted with sharp stakes and others of the same kind were fixed in the bend of the river beneath the water.' With these defenses, the Catuvellauni tribal leader Cassivellaunus would have positioned his men along the riverbank between Cowey Stakes and War Close Field, an area of Shepperton now known as Lower Halliford. This stretch of river has a series of very distinctive bends (more later). In documentation by the Anglo-Saxon historian Bede, Stukely, Salmon and other eminent antiquarians, War Close is described as a field where 'spears, spurs and bones have been found ... the field of battle between Caesar and Cassivellaunus'. Roman coins have also been found in a ditch skirting the northern edge of War Close Field.

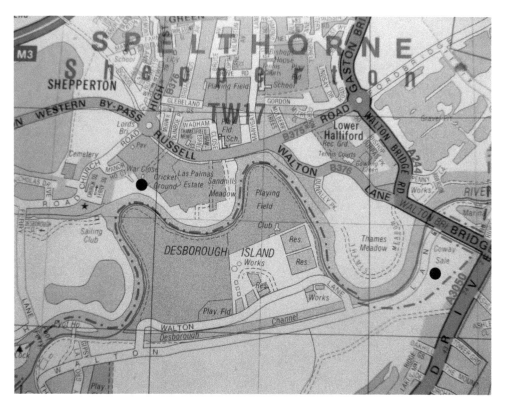

Map of the area where the Romans crossed the Thames and where the conflict between the Romans and the Catuvellauni tribe took place.

The eighth-century chronicler Bede expounds the stakes described by Caesar as 'formed of the entire bodies of young oak trees ... each about 6 foot long ... in two rows as if going across river. 9ft apart as water runs, 4 ft apart crossing the river.'

There was no further mention of Cowey Stakes until William Camden, the antiquary and historian in *Brittania* (Gibson's translation) 1695, pronounced his conviction that 'tis impossible I should be mistaken in the place – where the battle between the Celts and Caesar took place – because here the river is scarce six feet deep, and the place at this day from these stakes is called Coway stakes.'

William Camden was held in high esteem as a historian and his views were readily accepted and repeated by the likes of John Milton, the poet.

For the stakes to have been in evidence for so long, it's likely that the Cowey Stakes had another practical though less mundane purpose. In all probability, the name Cowey is derived from a cattle track or cow way, and it was customary to use two lines of timber posts to indicate a cattle track fording the river and across marshy ground.

A considerable number of stakes were taken from the bed of the river between the sixteenth and nineteenth century as they impeded river traffic. One stake 46 inches (1.17 cm) long and 3.25 inches thick (8 cm) was taken from the river in 1777 and presented to the British Museum. According to *The Book of the Thames, 1859*, 'when the water is low and clear, some of the fragments, it is said, may still be seen imbedded in the clay; others have been taken from the river, black with age, but still sound.'

Without obvious evidence of the stakes, the recreational area beside the bridge between Shepperton and Walton had a name change from Cowey Stakes to Cowey Sale. The name

Eel traps.

sale is derived from sallow, another name for osier or small willow, plants that grew in profusion along this stretch of the river. After coppicing, the long flexible shoots known as withies provided local basket makers with the raw materials for their trade. For centuries, wicker baskets were the principle form of container for carrying goods, and withies were in demand all along the river for making eel traps, fish weirs and crayfish pots.

And just a final note to the story of the stakes, under the title *Biographical and Literary Anecdotes of William Bowyer*, first published in 1782, it states that 'cutlery with oak handles that had formerly been the stakes at Cowey Sale were presented to William Bowyer by The Right Honourable Arthur Onslow (1691–1768), the Speaker of the House of Commons.'

The Middle Ages

Although the Roman occupation lasted nearly 400 years, it has left very little evidence in the area. Waterlogged and wooded soil alike were avoided when there were more fertile plains elsewhere. The Dark Ages followed, historically a confused and chaotic time when we can't accurately detect what happened, but also a time when its alleged that Middlesex received its pattern of villages and market towns. 14,000 small, self-sufficient village communities were founded, including Shepperton, which is a Saxon name meaning 'shepherd's habitation'. The London and Middlesex Archaeological Society have identified four Saxon burial grounds in Shepperton.

In May 1967 when the former Rose Acre Nurseries, south of Briar Road, was being excavated for a new junior school, workmen found a skeleton. The police were called and duty police surgeon Dr David Foster was able to rule out any recent foul play, so the authorities contacted the Museum of London. They identified the skeleton as being over 1,400 years old. This led to an archaeological dig, which revealed part of a Saxon settlement, seventeen small artifacts and a burial ground reaching as far as the end of Thornhill Way where it meets Sheepwalk. Sadly, all the land around has been disturbed. Not only is there housing, the south and west has been extensively quarried for gravel, obliterating the possibility of more finds. The subsequent primary school was named Saxon School.

An early engraving of bronze decorative brooches and hair pins found in a Saxon tumuli at Shepperton (woodcut from 1859).

It's likely that there has been continuous settlement in the area since the fifth century because dense forests made it impossible to move around unless by river. On 27 March 1817, a village labourer named Francis Cook discovered remains in a gravel pit in the upper West Field on the right of the Shepperton/Chertsey road. The finds consisted of an urn, a dagger, the hilt of a sword and the head of an axe, as well as many human bones and skulls dating from ninth-century clashes with Danish marauders.

Shepperton is mentioned in a document of 1 April 959 in which 'the possession of Sceptune was bought from Aelfleda for 60 monies of Byzantium (about £54)' and given to the abbots and monastery of Westminster. The church retained overlordship from the mid-tenth century until the Dissolution of the Monasteries in the sixteenth century.

In the Domesday Book of 1086, Shepperton is listed as an agricultural village with a fish weir between Shepperton and Walton valued at 6s 8d per year. These fish weirs were hurdles of woven willow set in the river to form a fence to trap fish. Not only did they destroy large numbers of smaller fish they also obstruct river traffic and in 1197, it was decreed that all fish weirs on the Thames should be removed. A similar clause was written into the Magna Carta in 1215 but to no avail. Fishing weirs, fastening nets and other forms of trapping (kydells and trinks) continued. Fishing provided food and livelihood, but disputes over fishing rights were frequent. In 1521, men of Walton and Shepperton appealed to the Lord Chancellor, Cardinal Wolsey, claiming that fishing provided their only means of gaining a living and they were too poor to sue or defend their cause.

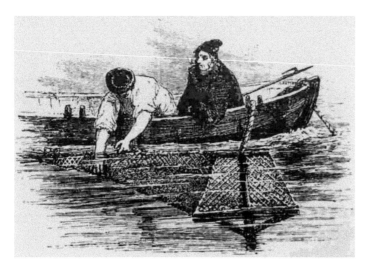

Fishing provided food and livelihood (woodcut from 1859).

In a charter of 1227, Shepperton, like many other village communities, still relied upon agriculture with most men being employed as agricultural labourers, fishermen or watermen. This changed very little over the proceeding centuries as the population increased from 100 in 1086 to 270 in 1664. For centuries the traditional rural economy embraced a rich diversity of crafts and trades which, between them, satisfied most of the material needs of the local community: a mill, a malthouse, a tanyard, a rope yard, a smithy and several boat yards along the river.

It's difficult to judge how important sheep farming was to the village's economy, but there is evidence in names like Sheepwash, leading down to the Thames where sheep had their annual dip after being sheared. Middlesex wool is included in a valuation of 1343, with the comment that being marsh wool, its value was less than wool from the midlands. Things were said to be so bad that most of the sheep had to be sold and the land was lying fallow.

Even into the 1800s, the small, scattered hamlets of Sunbury, Halliford, Littleton and Shepperton practiced a farming economy that hadn't changed significantly for generations. Probably oxen were still used to plough the fields but things changed when the Enclosure Act came into force. Heathland was gradually reclaimed using the paring and burning system in which the vegetation was cut down and burnt producing an estimated 2,000 bushels of ash per acre that was ploughed back into the soil alongside dung and rotting vegetables. To produce fertile arable land, special barges brought chalk, peat and ash downstream to Shepperton, and huge quantities of manure were brought upstream from London where horse-drawn transport predominated and manure was an inevitable nuisance. All these commodities nourished farmland that in turn grew hay to fuel London horses and produce for the London markets. When the railways reached Shepperton in 1864, this manure was brought in by train and from the station it was delivered to the various growers in small horse-drawn carts that ran on rails set into the side of the road. It was not until the 1930s when motorised transport took over from horse power that artificial fertilisers were used in any quantity.

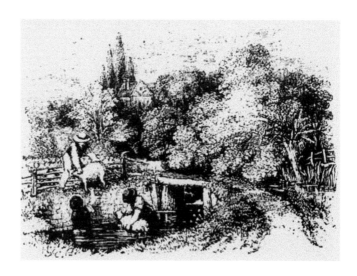

Sheepwashing in the River Thames. From a woodcut by W. E. Bates taken from the Book of the Thames by Mr and Mrs S. C. Hall (1859).

Mixed farming was gradually replaced by market gardening and by 1874 there was 81 acres of orchard in the area. By 1914, that figure had risen to 373 acres. The main orchard crops were apples, pears, plums and greengages with an equally rapid development in the growing of soft fruit. Because Shepperton was predominantly an agricultural community right into the twentieth century the only industries were those connected to this like blacksmithing and wheelwrights. In 1841, over 55 per cent of the working population were classified as agricultural workers, 14 per cent were classified as gentry and almost 30 per cent were domestic servants.

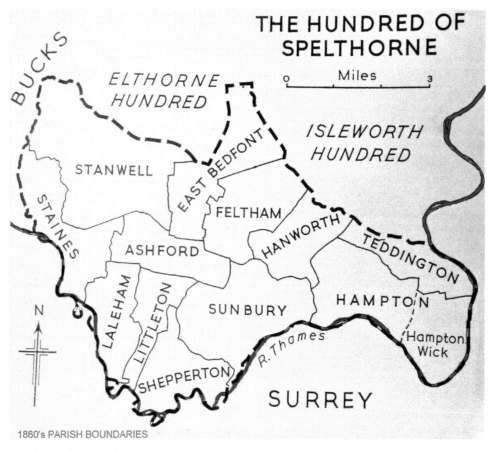

Parish boundaries in the 1860s.

2. The Iconic River Thames

Because of its strategic position on the north bank of the River Thames, Shepperton's history has always been inextricably linked with the river. It provided food, livelihood and transport but dependent upon the strength of the current moving downstream or upstream, journey times were unpredictable. There is a sixteenth-century document stating that the state of the river was becoming a danger to navigation due to the pollution of the water and the damage to the banks. Flooding has always been a problem and as far back as 1504, money was being left to defend the parish from flooding by the river. The area at the southern end of the High Street where the war memorial now stands was marshy land prone to flooding and Lord's Bridge was built to try to alleviate the problem. Lord's Bridge was first mentioned in a document of 1604, and there is a mention in the Manor Court Records dated 1 October 1651 stating that 'the two bridges called Mayes Bridge and Lords Bridge are in great decay, the jury humbly desire the lord that they may be speedily repaired.'

Despite these footbridges being built to enable the residents of Old Shepperton on the south side to get to the High Street area on the north, it would appear that this wasn't always possible. At times of flooding, people used their initiative and apparently boys used home-made stilts to 'run errands' through the floods. In 1822, large areas of low-lying land were flooded and punts were used to convey people stranded by flood water to and from their homes. In 1894, flooding was so bad, it was recorded that a punt could be taken over the roads from Walton bridge to Chertsey bridge without getting grounded. Lord's Bridge disappeared in 1987 when Shepperton's Western bypass was constructed. The Shepperton war memorial stands on the roundabout subsequently created at the southern end of High Street.

The High Street looking north from the former Lord's Bridge.

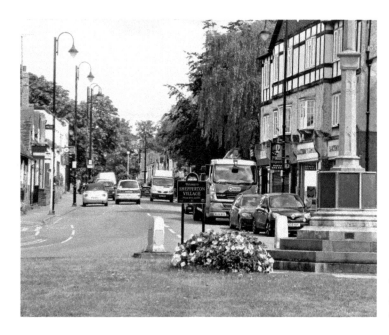

The same view
as previous page
seventy years later.

DID YOU KNOW?
At the Lord's Bridge roundabout, a previously neglected patch of overgrown land has been turned into a pocket park, exposing the little stream that previously flooded the area. An old dinghy named *Jeanette* forms a delightful flower container, and standing guard alongside the seat is a 6-feet-tall aluminium silhouette of a First World War soldier complete with gun and fixed bayonet. His head is bowed and a poppy adorns his chest in silent remembrance of the 888,246 British and Commonwealth soldiers who died during the First World War. These silhouettes were erected by the British Legion to mark the 100th anniversary of the end of the war.

With flooding of low-lying areas being all too common, the river towpath was regularly washed away and deposits of sand and shingle caused shallows to form in the barge channel. Barge owners complained, especially after the floods of 1774 and the necessity to pay tolls, but very little was done.

The typical Thames sailing barges could be anything from 40 to 200 tons. The small narrow boats were called 'worsers' or 'wussers' and the 'stimpie' was a smaller barge that could be used in the upper reaches. Watermen travelling beyond the movement of the tide referred to it as travelling west, so the barges were known as West Country Barges. Most of the cargoes passing through Shepperton were on their way to London – grain, building materials, manufactured items, paper, coal; the list of cargoes was not only varied it was immense.

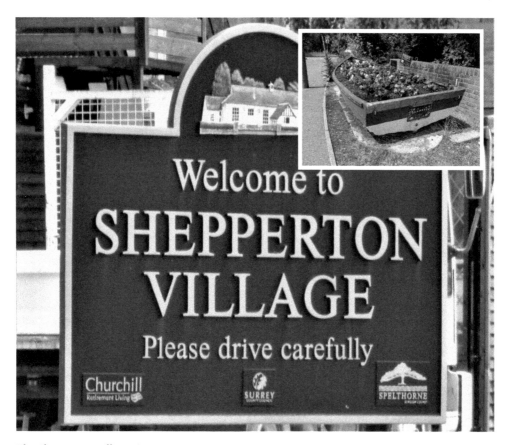

The Shepperton village sign.

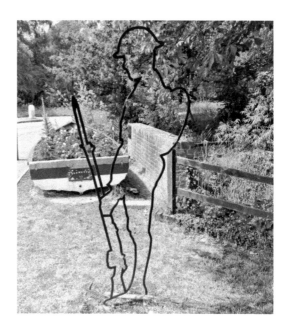

The pocket park by the former
Lord's Bridge.

The river is still used as a means of transporting bulky items like this unfinished Thames riverboat ready for siting.

Rope-making is an ancient craft of vital importance for local agriculture and rivercraft in riverside villages and at Shepperton, a local rope walk existed by the present Glebelands Gardens. Ropes had to be replaced regularly as a set of barge ropes would only last three or four return journeys to London. Barges hauled by gangs of fifty to eighty men called haulers/halers were used until the late eighteenth century when horse towing became more widespread. Twelve to fourteen horses did the job of fifty to eighty men.

At Shepperton the towpath changes from the north bank to the south bank and halers would cross the river using the public wherries, which operated from Ferry Square lying adjacent to Church Square. This subsequently became a staging post where the watermen would gather. W. S. Lindsey wrote: 'there was a superabundance of public houses and beer shops to supply the villagers and thirsty bargemen who then congregated here in large numbers.' These alehouses are still in abundance with Ye Olde King's Head and The Anchor both claiming to date from the sixteenth century.

The earliest recorded ferryman was Clement Coomes, mentioned in 1586. In 1691 William Atwick is recorded as ferryman and from the eighteenth century, the Purdue family were boat builders and ferrymen. Purdue's boathouse was pulled down in the late 1950s to make way for an extension to the Warren Lodge Hotel. The valuable right to operate wherries was jealously guarded with accommodation wherries intended only for passengers and navigation wherries for passengers, livestock and goods. In the Middlesex Session Rolls, dated 27 October 1629, it states that John Parryn, waterman of Maidenhead, had to appear at the next gaol delivery to answer charges

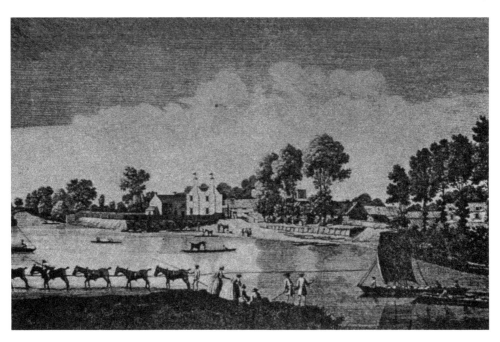

A barge being pulled, with a horse being wafted across the river and others waiting on the far bank. Note the church tower between the trees, which dates to *c.* 1750.

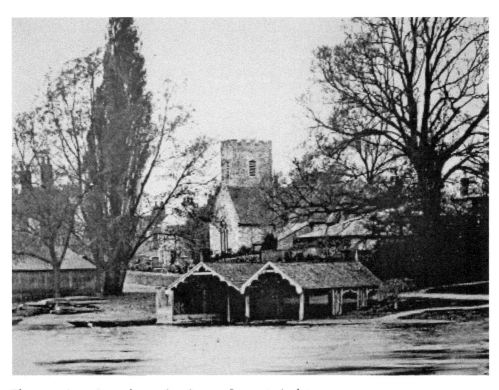

The same viewpoint as the previous image a few centuries later.

Above and left: The former ferry landing stage is now available for public launching but take care – its slippery.

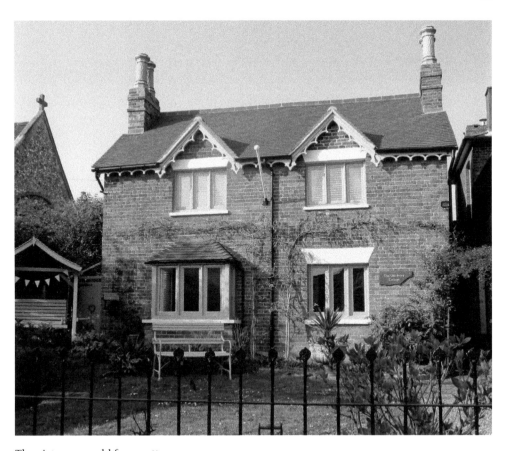

The picturesque old ferry cottage.

that he had overloaded his wherry with wares and passengers, 'willfully or negligently drowning nine people out of his wherry between Chertsey Bridge and Shepperton on 22 October last.'

As previously seen, the shallow water of the river at Shepperton enabled people and animals to cross by ford, but barge owners had been complaining about the shallows around Shepperton for centuries. After a long dry spell the depth of the river water was not more than 2 feet 8 inches (80 cm) and barges laden to the customary draft of 3 feet 10 inches (1.15 m) were frequently stranded. This was not only a nuisance; it delayed journeys and, like our present-day motorway hold ups, a long tail back of traffic would soon build up.

Things changed from 1770 when the lock system in the upper Thames was developed. Originally locks were flash locks with only one gate that when opened caused a 'flash' of water to be released. This enabled the flotation of any barges or other craft that had become grounded, but after this wall of water had been released, it left the water very low. Pond locks, which we know today, were developed with a pair of gates. When the lower gates are opened, the top gates hold water back as the water in the 'lock' between is released.

The Shepperton Lock sign.

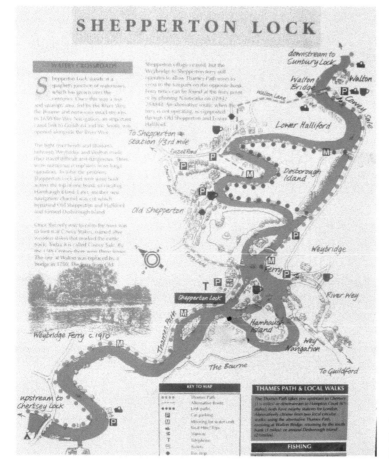

The information board at Shepperton Lock.

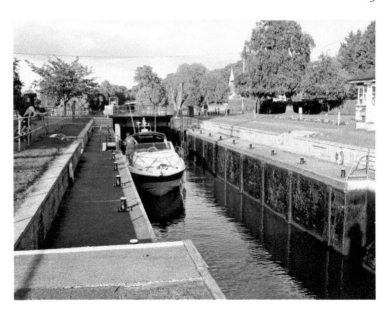

Shepperton Lock.

By the 1810 Act for the improvement of the navigation of the river, permission was granted to construct Shepperton Lock, 30 miles 3 furlongs from London bridge. It was opened to river traffic in January 1813 and rebuilt in 1900 with a 5-foot 3-inch fall in water level. William Hatch was the first lock keeper. By this time, horse towing was widespread but the barges were often delayed because the horses were forced to leave the river and go by road to Ferry Square where they could cross the river. This prompted William Hatch to commission a specially enlarged ferry to operate from where the towpath ends at Shepperton Lock and began again on the opposite bank, able to carry or 'waft' horses, carts and carriages. Understandably, William Dowton who operated the Church Square Ferry, complained that he was suffering a loss of income and for some considerable time there was disagreement until it was agreed that Hatch could continue as long as he took only the boat horses and no passengers. William Hatch served forty-six years as Shepperton Lock Keeper and was pensioned off in 1859.

In 1861, further complaints that the lock ferry was again taking passengers were made and in 1863 a petition was made to relocate the Shepperton ferry to the lock. The Thames Conservancy agreed, and Ferry Square continued in name only as the road leading to the Lock Ferry became Ferry Lane. In the 1920s, George Dunton owned the boatyard by Shepperton Lock, offering boat hire and a riverside café, and operating the ferry until around 1960 when the service ceased. Nauticalia acquired the George Dunton business and boatyard in 1986, and Lynn Lewis, the owner of Nauticalia, reinstated the ferry, which now runs every fifteen minutes on request and is a recognised part of the official Thames Path. It's very pleasurable to browse the varied, interesting items in Nauticalia and have light refreshment or cream tea served on the lawns at Shepperton Lock while watching the antics of the boaters struggling with the lock gates.

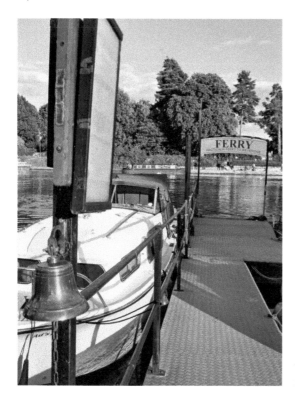

The ferry landing stage – note the bell to ring to summon the ferry.

A sign of the times.

Who will you be catching the
ferry with?

The Eyots of Shepperton

Shallows had always been a problem in the river and over time as sand and shingle accumulated, they formed small river islands known as eyots or aits. An ait is characteristically long and narrow and starts naturally. A channel with numerous aits is called a braided channel and in previous centuries these river aits were rented to basket makers and planted with osiers/willows for their use. Now they are established with permanent housing.

There are five river aits in the Thames at Shepperton, although technically Hamhaugh Island is not an ait as it was not formed this way. Prior to the first Shepperton Lock being built in 1913, Hamhaugh Island was a promontory from the bank known as Stadbury Meadow, owned by George Dunton, whose boatyard was across the river at the end of Ferry Lane. He was not allowed to build any permanent structure on the island but he rented out camp sites in the summer months. When Jack Dunton inherited the island, he decided to divide it up and sell forty plots giving the first options to the regular campers who from 1920 onwards began to build holiday homes, which later became permanent. It is necessary to cross the lock to Lock Island, then the weir to reach Hamhough Island.

Until 1812, the lower part of the waterway that is now Shepperton Lock Cut was a creek known as Stoner's Gut. During periods of high flood, the strip of land between the river and the creek was frequently breached, and the river altered course to flow through the gut. The island so formed was called Stadbury Ait, now known as Lock Island. Here is the lock keepers cottage, tea rooms and the HQ of Weybridge Mariners.

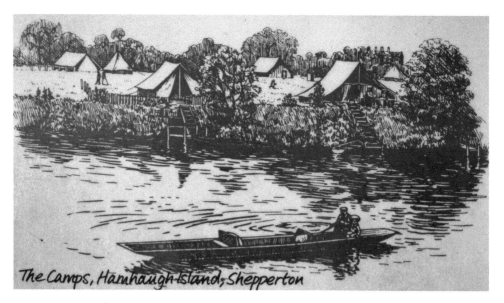

Campsites on Hamhaugh Island.

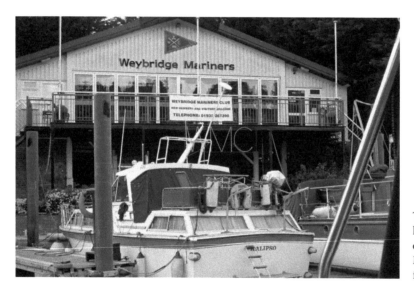

The headquarters of Weybridge Mariners seen from the river.

The oldest true ait is probably Pharaoh's Island. Its former name was Dog Ait and the lane linking the towpath with Chertsey Road was originally called Dog Ait Lane. It's now Dockett Eddy Lane. Dog Ait also had a name change to Pharaoh's Island in 1903 when the first house was built and named The Sphinx. Now most of the islands twenty-three privately owned homes have Egyptian names but what's the connection with Egyptology? 1903.

Pharaoh's Island accessed by boat.

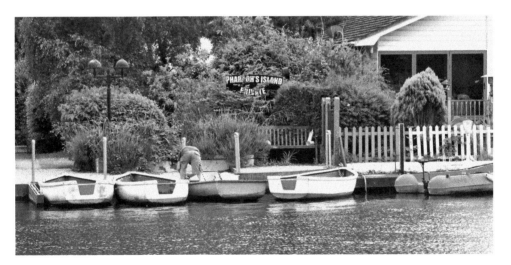

Pharaoh's Island.

DID YOU KNOW?
There's a local legend that Dog Ait was purchased by the treasury and given to Admiral Lord Horatio Nelson as a thank you from a grateful government after he defeated the French fleet at the Battle of the Nile in 1798. It's known that Nelson was keen on fishing but is it fanciful to think of him sitting there in solitude with his rod in his hands, or rowing his lover Lady Hamilton across the water to a secluded love nest?

In 1794, the D'Oyly Carte Island was called Folly Ait with a name change in 1885 to Silly Eyot, with the channel on the north side then being referred to as Silly Cut. Originally no more than a sandbank, the ground level was raised by gravel excavations dredged from the riverbed when the first lock at Shepperton was constructed in 1812. During the 1880, the eponymous owner Richard D'Oyly Carte, the Simon Cowell of his day, gave the island his middle and surname. He had the banks strengthened and built a house on the island. Richard D'Oyly Carte was founder of the Royal English Opera House, now the Palace Theatre, and the Savoy Theatre in The Strand, London, where the D'Oyly Carte operettas were performed. He then built the Savoy Hotel to accommodate the theatregoers, and continued to build up a property empire by developing Claridge's, Simpson's-in-the-Strand and The Berkeley hotel. He intended to make a secluded annex of the Savoy Hotel on the island but his plans were thwarted because he was unable to obtain a liquor licence. Undeterred, the eleven-bedroomed Eyot House remained his private residence where they held theatrical productions in the 40-foot ballroom, and put on impromptu outdoor performances for local residents, who watched from the opposite riverbank.

DID YOU KNOW?
Many famous people were entertained at Eyot House, including dramatist William Gilbert and composer Arthur Sullivan. Another celebrity guest was Sir James Matthew Barrie who in 1904 created the story of Peter Pan. Being pursued by pirates, Peter Pan sliced off the hand of Captain Hook that was swallowed by a crocodile who pursued him for second helpings. The crocodile's inclusion in the story was said to be D'Oyly Carte's contribution as he was fascinated by crocodiles and kept one as a pet on the island. He also had a crocodile carved alongside the gargoyles on Eyot House.

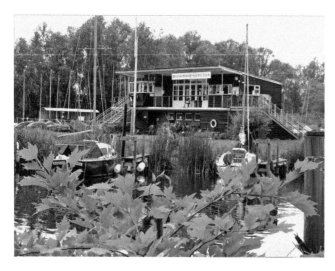

Desborough Sailing Club.

Desborough Sailing Club started on D'O'yly Carte Island facing the Desborough Cut, but in 1951 the club outgrew this site, and land was leased bordering The Creek. Two years later, further land was acquired giving a main river frontage, a club house and slipway. Club membership was high in the 1960s but since the popularity of paddle boarding, new potential dinghy sailors have not been attracted to join. Another new sport, white water and slalom canoeing, can be found by Lock Island below Shepperton Lock weir. Coloured poles suspended from overhead wires mark out the slalom course, which is used for training purposes and competitive events. It can be tricky when the stream is moving fast and is for experienced people only. The British Olympic team have trained here. The smaller weir stream from the River Wey is used for training beginners.

The previously mentioned Desborough Cut, named after Lord Desborough of Taplow, the Thames Conservancy Chairman from 1904 to 1937, is an 80 feet wide, man-made channel dug in 1930–1935 to ease flow, help prevent flooding and improve navigation round the Shepperton/Halliford bends. It provides a straight course for 0.75 mile and is the only stretch on the river where there are two alternative main navigation channels.

The island so formed was named Desborough Island. At the time, the land was owned by a M. S. Brown, who lived at Brownlands and ran a zoo named Brownacres. The zoo was disbanded in 1939 at the outbreak of war and the land became Vandals Rugby Football Club. The eastern end of the island is now the Desborough Water Works, pumping station and reservoir, the remainder is rough field and a circular walk round the island is a favourite with dog walkers. There are also two secluded beaches that run down to the river.

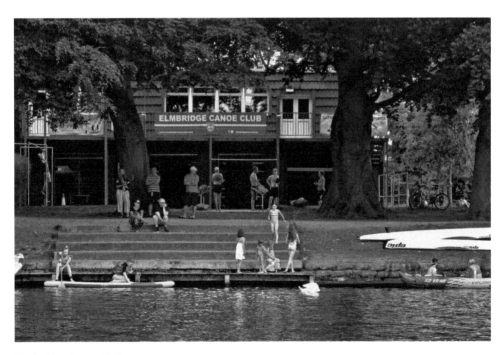

Elmbridge Canoe Club.

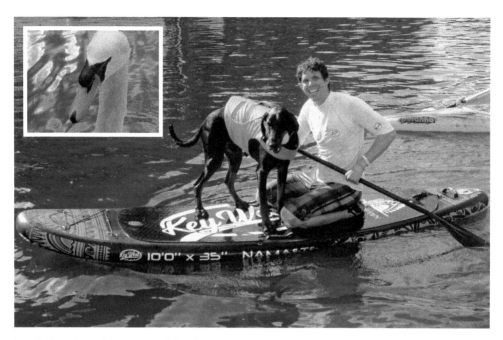

Paddle boarding with your best friend.

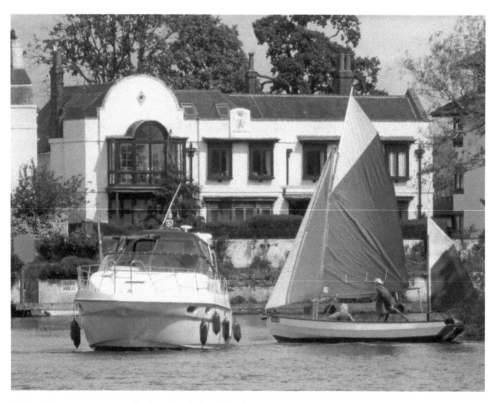

Sail and motor power on the busy Halliford Bend.

Desborough Cut is an alternative straight course.

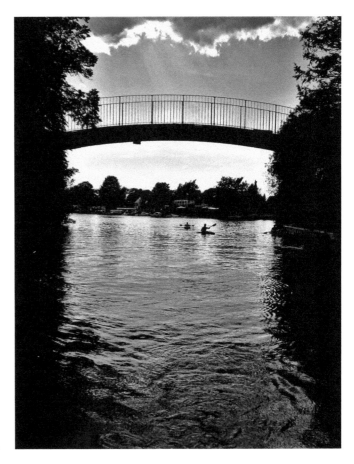

Atmospheric River Thames.

Swimming in the Thames is not recommended, yet many do. The Thames is deceptive with its currents and eddies that can be dangerous, and it's a sad fact that more people drown in the Thames than in the rest of the rivers and waterways of Britain combined. Swimmers use the river to cool off on sizzling summer days, and some hotheads use the footbridge at the end of the Desborough Cut to jump from. Without luminous buoyancy aids or caps, swimmers can't always be seen by boaters and can be a cause of great concern.

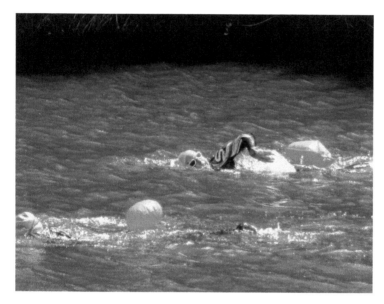

Swimming can be dangerous unless prepared.

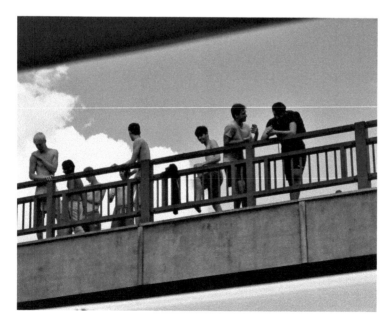

Swimmers getting ready to jump into the river from the footbridge to Desborough Island.

DID YOU KNOW?
Desborough Island and the surrounding river were used for filming the video by
Culture Club for its 1983 song Karma Chameleon. Actors in period dress from the
1870s stand on the banks of the island waiting for the Mississippi paddle steamer
as it steams up Desborough Cut.

On the stretch of river can be found swans, mallards, geese, great crested and little
grebes, the shy moorhens and coots, Canada geese and Egyptian geese. The great crested
grebe is a delightfully elegant waterbird that dives to feed, and also to escape, preferring
this to flying. They were almost driven to extinction in Victorian times because their
ornate head plumes led to them being hunted for their feathers to be used in elegant
ladies hats. This promoted the establishment of the RSPB in 1889.

During the summer months, until 2020 when all such activity was forced to stop, there
was a regular sightseeing trip round Desborough Island from Cowey Sale. Trips resumed
in July 2020.

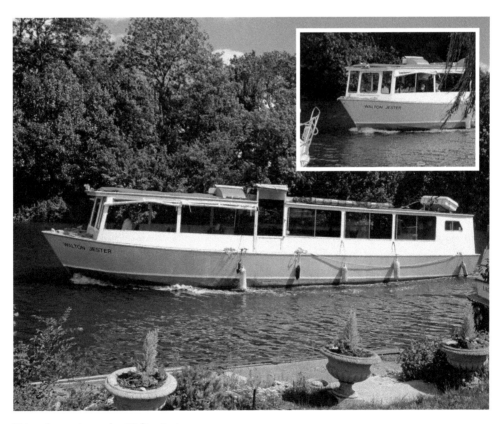

Take a boat trip on the *Walton Jester*.

Another victim of the COVID-19 pandemic is the Shepperton Village Fair cancelled for the first time since its formation in 1973. Run by dedicated volunteers, the day provides a great day of attractions for many in and around Shepperton beginning with a procession to Manor Park where the main events take place. And what could be more memorable than the Raft Race beginning at Nauticalia and ending at War Close.

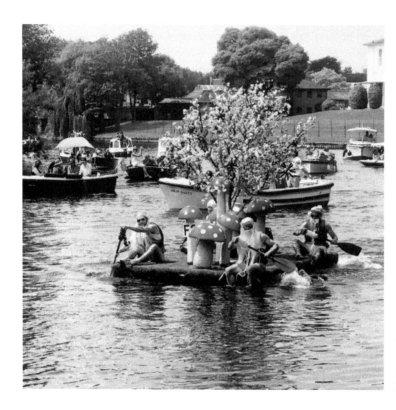

Friendly rivalry in the annual raft race. (With grateful thanks to Kim Fahay)

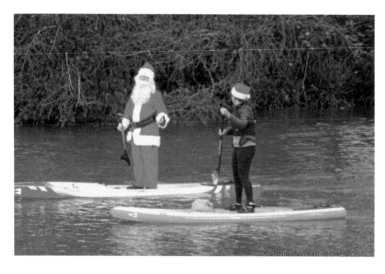

Santa comes by river in Shepperton.

The Tale of Six Bridges, 1750–2013

Despite much opposition from the ferry operators and those who had vested interest in other riverside activities it was suggested that a bridge should be built across the river. It was necessary to obtain an Act of Parliament before the work could proceed but in August 1750, the first bridge linking Shepperton and Walton was finally completed and opened to the public. The bridge was positioned at Halliford, the south/east region of Shepperton that borders the Thames, and in *The Thames and its Story* (1937), they refer to it as the old Halliford bridge. This was a latticed timber construction with three arches supported on stone piers with brickwork approaches on each side spanning part of the marshland beyond. The picture quality of the bridge attracted artists like Caneletto who painted it on two separate occasions.

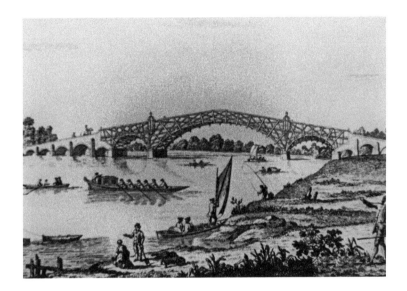

The first
Halliford Bridge.

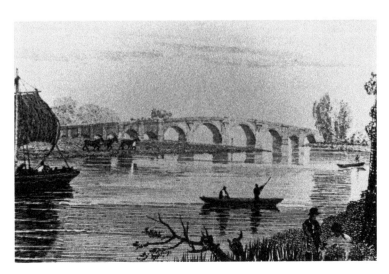

The second
Halliford Bridge.

After only thirty years the concern for the bridge's safety and the cost of repairs had become excessive, so a new bridge was proposed. Completed in 1786, the replacement brick bridge was designed by James Paine, who also designed the bridges at Richmond, Chertsey and Kew. It was painted by many artists including Joseph Mallord William Turner but in August 1859 a crack appeared across the central arch and parts of the bridge fell into the water. The necessary repairs were not carried out, the bridge fell into ruin and for four years Shepperton was without a bridge, a situation that ultimately led to the building of a railway line to Shepperton.

It was not until 1864 that a third bridge, a latticed iron girder construction with four spans supported on brick and stone piers, was finally opened. In *Dickens's Dictionary of the Thames,* 1885, it says 'An iron bridge connects the counties of Middlesex and Surrey at Halliford; the old brick bridge, with its numerous arches, having succumbed some years ago in a disastrous flood.'

In *The Thames and Its Story* (1937), it states, 'Halliford Bridge was washed away some years ago by the floods (1859) and now, about half a mile below Halliford, the Surrey and Middlesex shores are connected by a brick and iron structure which is named Walton Bridge.'

The third bridge was described at the time as an ungracious structure and later as the ugliest bridge on the upper reaches of the river but it survived until damaged by enemy action during the Second World War. Due to this, it was unsafe for heavy traffic and load limitations were in force until 1953 when a temporary bridge was erected. The temporary fourth bridge was capable of carrying the load of modern commercial vehicles but was not wide enough for the volume of traffic, so after much deliberation it was decided to build a fifth bridge. The fourth bridge was retained for use by cyclists and pedestrians when the fifth bridge was opened for vehicular traffic in 1999, but there were soon structural problems that led to much traffic disruption. There was heavy criticism that led to demands for construction of a sixth bridge, completed in July 2013 at a cost of £32.4 million. Perhaps at last Shepperton and Walton will be linked by a bridge that is capable of standing the test of time.

DID YOU KNOW?
Between 1750 and 2013 Shepperton and Walton had been linked by five distinctive, though doomed, bridges.

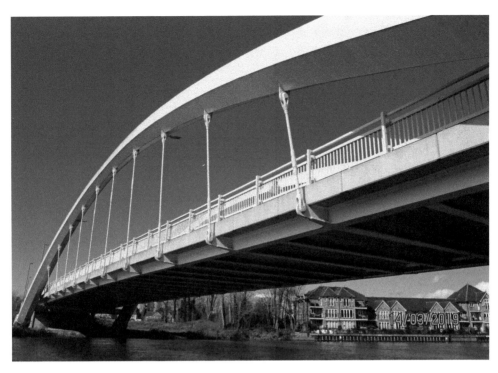

The impressive sixth bridge to cross the river.

The mast just clearing the bridge.

3. The Railways and the Changing Face of Shepperton

In this day and age with the extraordinary migration that takes place, it's hard to realise that until recent centuries most villagers never left their village unless it was to go to market or for other commercial reasons. Only the wealthy had the need and means to travel, and as Shepperton was not on a main road it missed the heyday of the eighteenth and early nineteenth century stagecoach. Wealthy residents undoubtedly had their own carriages and coaches but the roads were in a poor state and river travel predominated until the mid-nineteenth century and the coming of the railways.

From 1830 to 1900 inventive skill and new capital was devoted almost entirely to the building of railways, but the railway was late to arrive in Shepperton. When the idea was first voiced, a farmer of Watersplash exclaimed in amazement 'A railway!. Why, a donkey cart would take all the goods and all the passengers that go between London and Shepperton in a month.'

It was undoubtedly the inconvenience caused when the bridge collapsed in 1859 that prompted the village squire William Schaw Lindsey to get involved in promoting the railway line to Shepperton. He became chairman of the Metropolitan and Thames Valley Railway Company, which was formed in 1861. The following year the title was shortened when the Metropolitan prefix was dropped from the name, and the Thames Valley Railway Company was given permission to proceed. It opened in November 1864 as a branch from Strawberry Hill through Fulwell, Hampton and Sunbury to Shepperton.

Although the railway meant easier access to London, it was still too expensive for most villagers when a workman's average wage was less than £1 per week and the fare to London was 1s 3d (6.5p). In 1916, the railway line was electrified and gradually the steam trains were replaced. In 1926, it became part of the Southern Railway. Even from the very early days of the railway, Londoners started coming out by train to enjoy the relatively unspoilt reaches of the river, to sail, fish or picnic on the riverbanks, and Shepperton became known as the playground of London.

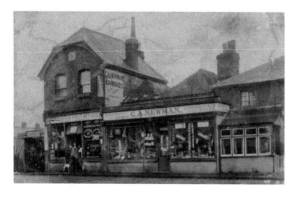

Shepperton's post office and general store in the early 1900s.

DID YOU KNOW?
In the 1890s Charles Alfred Newman established a business at the bottom of High Street, now the site of Lordsbridge House. It was the post office and general store selling every conceivable commodity that a village could need and also catering for tourists. Postcards like the one above was popular but there was also a roaring trade in small commemorative pieces of china decorated with the colourful coat of arms of Shepperton. These pieces, produced by William Henry Goss of Stoke on Trent, were popular souvenirs for the people flocking to Shepperton. Note in the photo, a lean-to on the main building housed a horse and carriage used as a taxi to transport visitors to and from the station.

In the early years of the nineteenth century, the river had been an important commercial waterway, carrying considerable volume in barge traffic, but by the 1880s with stiff competition from the railways, barge traffic had virtually been driven from the waterways and recreational facilities had taken over. In his book *Victorians on the Thames*, R. R. Bolland records that by 1888, there were 250 new luxury steam launches on the river. In 1889 there were 12,000 small pleasure craft registered by the Thames Conservancy in addition to the palatial houseboats, which were moored along the banks, and the large number of skiffs and punts in use on the river. By the latter years of the twentieth century, several thousand pleasure crafts were passing through the various locks on this stretch of the Thames on an average summer Sunday.

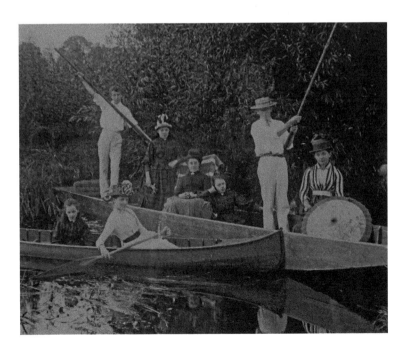

Edwardians boating on the river.

Shepperton's ancient pubs and hotels were ready to cater for this influx of visitors and on the Halliford Bend of the river was The Ship and The Red Lion. As well as the usual facilities on offer, The Ship had stabling for five horses with loft over, a coach house and loose box. Despite the perilous state of the roads and the possibility of flooding, Russell Road was and still is the main road linking Walton and Chertsey. From the 1820s a twice-daily coach service passed through Shepperton and there was also a carrier service to London three times a week. It was recorded in 1893 that The Reliance coach that normally ran from Teddington to Box Hill ran to Ascot for the Royal Race meeting, changing horses at The Ship in Shepperton. By the early twentieth century, the stables were converted to garages to accommodate a new form of transport – the motor car. With six bedrooms, together with a WC and a bathroom, The Ship also advertised accommodation for gentlemen rowers, anglers and tourists. The Creek opposite was dredged and widened in the 1890s to allow steam launches to come up to moor and refuel at the small coal yard offering Welsh smokeless steam coal, but a century later, the Ship Hotel was demolished and apartments built.

Two doors away was the Red Lion, a much smaller establishment but now a very popular place with a garden on the opposite side of the road overlooking the river. Records at the Red Lion state that in 1857, seventy-eight barrels of beer were consumed, rising to 127 barrels in 1860 and 195 barrels in 1883. A 1893 advert in *The Lock Times* stated that there was 'accommodation for anglers, launch and boating parties. Boats and punts – with or without tackle – always in readiness.'

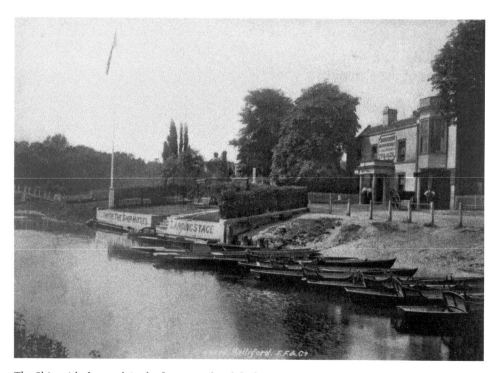

The Ship with the creek in the foreground and the boats ready for hire.

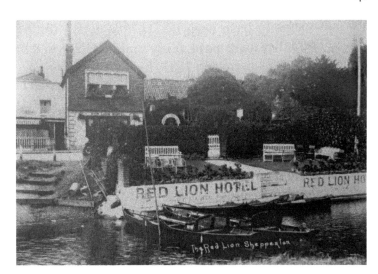

Red Lion and riverside garden.

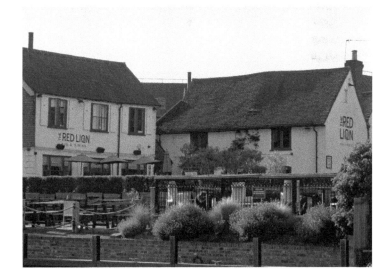

Red Lion today.

Sandwiched between The Ship Hotel and The Red Lion was Eyot Cottage, the base for the Rosewell/Rixon boating business. They built and repaired river craft, and hired out skiffs, punts and fishing punts to people coming by train from London to enjoy the relaxed riverside facilities. From the landing stage at the pretty riverside garden on the opposite side of Russell Road they operated a ferry service. Eyot Cottage no longer exists as it became part of the Red Lion in 1950.

Prior to the railway era, the village clustered around the church in what is now Old Shepperton, but the railway line didn't terminate near there. Instead it ended a mile away where there was no settlement, prompting one person to write that the line terminated in a potato patch. It was said that the state of the district could be judged by the provision of a boot scraper built into the station building beside the booking office door.

All the buildings in Church Square, Old Shepperton, were erected before the nineteenth century, which gives this picturesque conservation area a relaxed, riverside village character. The architectural writer Sir Nikolaus Pevsner described it as 'one of the most perfect pictures that the area has to offer'.

Old Shepperton sign.

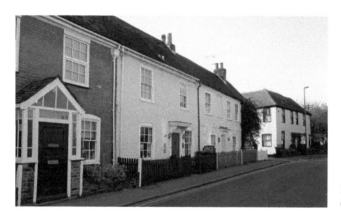

Picture-perfect properties on Church Square.

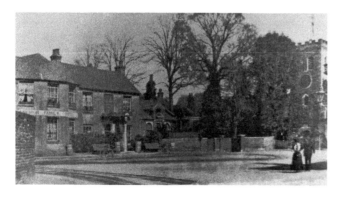

Church Square in the 1800s.

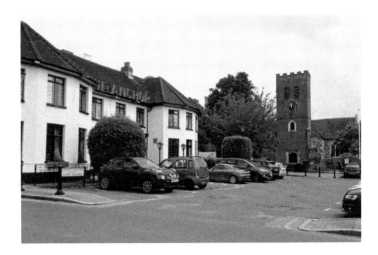

The same view today.

The Winches.

Although much renovated, The Winches on Church Lane, which perpetuates the name of the local barge owning family, is said to be the oldest domestic house in the village, and is one of only four houses in Middlesex described in Eric Mercer's *English Vernacular Houses*. Large residences along this part of Chertsey Road had ornamental gardens around them that have now been developed with more housing. The gardens at the corner house opposite the Anchor Hotel became the Anchor Service Station, owned in the early 1900s by the hotel. The canopy of the petrol pumps still survives as part of a car showroom with the sides glazed.

The Anchor Hotel in Church Square was said to have been frequented by the infamous highwayman Dick Turpin, yet few believed such stories until renovation works revealed a pistol hidden in the rafters bearing the chilling inscription 'Dick's Friend'. The original timber-framed inn was replaced in the 1800s with an extension added in 1899. It's believed that some of the panelling, which is such a feature of the ground floor, came from the original building with additions from Hughenden, Bucks, the former residence of Queen Victoria's favourite Prime Minister, Benjamin Disraeli.

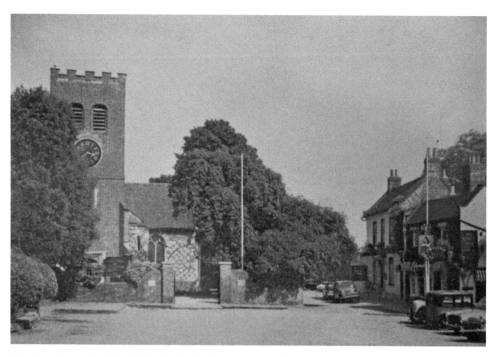

The church and the King's Head with the former Jesmond Cottage, now the Warren Lodge Hotel, in the background.

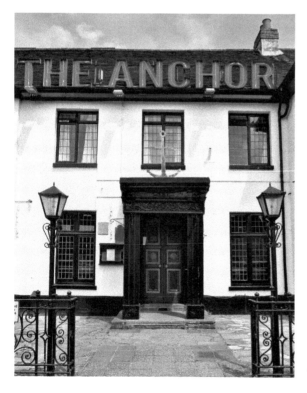

The entrance to The Anchor.

DID YOU KNOW?
The elaborate wooden entrance porch of The Anchor has an even more interesting provenance. It's said to have been the temporary structure erected at Westminster Abbey for the coronation of Edward VII and Queen Alexandra on 9 August 1902.

A severe fire on 3 April 1984 destroyed much of the right side of the inn but the subsequent rebuild, using modern materials, is so authentic it's appreciated by film-makers. With the world-famous Shepperton Studios just around the corner, many world-famous actors and musicians have stayed, dined or just popped in for a drink.

Ye Olde King's Head (now The King's Head) asserts a link with King Charles II, who wooed his mistress Nell Gwynne here. It's also alleged that Admiral Nelson courted Lady Hamilton here, and Charles Dickens is said to have stayed here and featured it in his novel *Oliver Twist* when Bill Sykes took Oliver and the dog Bulls Eye through Shepperton to rob a house in Chertsey. More recently, the pub has had many famous visitors, thanks to the nearby Shepperton studios, and the walls are adorned with photos of its famous visitors.

The Anchor is not only the name given to a nautical appliance made of metal to temporarily secure a vessel to the waterbed – it is also associated with St Nicholas, patron saint of sailors, and Shepperton's picturesque old church. The present church was completed in 1614 to replace a twelfth-century church that was, according to old records 'swept away by an inundation of the Thames'. The site of the earlier church is believed to be in midstream of the present river course. A hundred years later a tower was built and a clock was placed in the tower in 1769. The tower contains six bells, five of them dating from 1877 but when the tower was strengthened in 1980, the smallest bell named Little Nicholas was installed. In 1834, an external staircase leading to the gallery was added.

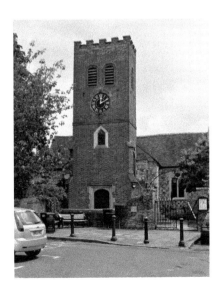

Shepperton church.

DID YOU KNOW?

DID YOU KNOW?
It's unusual to find an external staircase on a church but Shepperton church has two. One leads to the gallery and the second leads to the smaller Manor House Gallery over the baptistry, enabling the lord of the manor to leave the grounds of the Manor House at the back entrance leading to Church Square and enter his own pew without having to mix with the rest of the congregation. From this vantage point he could also keep a watchful eye on the congregation.

Despite being remodelled and enlarged in the eighteenth century, the old rectory can claim to be one of the oldest buildings in the village. Although it appears to be brick built, it incorporates a fifteenth-century timber-framed hall. The first records of the incumbents of Shepperton state that in 1504, Revd William Grocyn was initiated as rector of Shepperton. William Grocyn was a scholar and a friend of Erasmus, philosopher, theologian and Christian humanist, who is said to have visited Grocyn at Shepperton rectory.

The old rectory – now Erasmus House.

DID YOU KNOW?
The old rectory had a large lawn and kitchen garden, much of which has been swallowed up by the new rectory built in 2005, and the Parish Centre adjoining the church. No longer a rectory, the old rectory is now privately occupied and called Erasmus House, and as with many ancient buildings, it's said to have a ghost – none other than the great Erasmus.

Early church records show that the families of Reynell and Spiller occupied the old manor house during the seventeenth and early eighteenth century. Thomas Scott purchased the manor at the end of the eighteenth century and when he died in 1816, it passed to his nephew James Scott. It was he who built the present manor house on the site of the old one, and where he resided until his death in 1855. The following spring, the manor of Shepperton with lands, properties and the lordship was purchased by William Schaw Lindsay, Deputy Lieutenant of London, self-made man, shipping magnate and entrepreneur. He added to the size of the original estate until it was about 600 acres. The Manor House and estate remained in the Lindsay family until 1968. In 1962–63, all late nineteenth century and twentieth century additions were removed during a complete refurbishment, making it one of the most beautiful houses along the riverbanks.

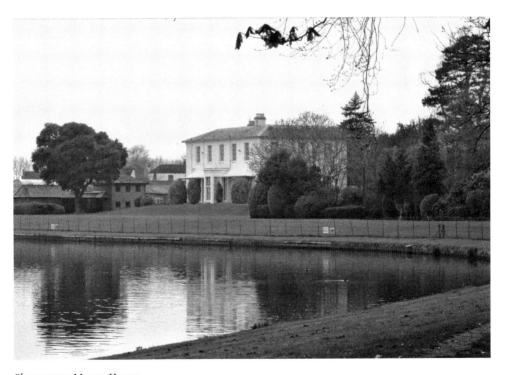

Shepperton Manor House.

Battlecrease Hall.

In the early nineteenth century, there were 420 houses in the parish. Most were the small, squalid dwellings of the agricultural workers, but sprinkled among them were mansion houses of particular note such as Dunally Lodge, Sunbury Court, Battlecrease Hall and Halliford House – now Halliford School. The latter hosted men of worldwide fame and royalty, and was the family seat of the Honourable Charles Francis Greville, second son of the then Earl of Warwick. His mistress Amy Lyon moved into his magnificent Georgian House at Shepperton and changed her name to Mrs Emma Hart. The painter George Romney was captivated by her beauty and painted her many times, giving her notoriety and superstardom. But by 1783, Greville needed to find a rich wife to replenish his finances and twenty-one-year old Emma became hostess to his cousin, the recently widowed fifty-five-year-old Sir William Hamilton, British envoy to Naples. They were married on 6 September 1791 and on 10 September 1793, as wife of the British envoy in Naples, Emma welcomed Nelson into their home. Five years later Nelson returned to Naples a living legend after his victory at the Battle of the Nile but he had lost his arm, most of his teeth, and was a sick man. Emma nursed him under her husband's roof, but a few months later, the gossip from Naples about their affair reached the English newspapers, and Emma Hamilton and Horatio Nelson became the most famous lovers in the world.

Halliford House.

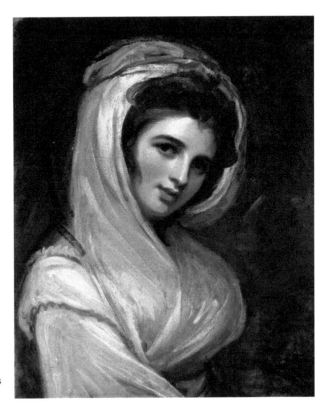

Lady Emma Hamilton, mistress
of the honourable Charles Francis
Greville of Halliford House.

DID YOU KNOW?

Shepperton has always attracted writers and artists, and many resident writers chose to write in the horror genre. In 1818, Thomas Love Peacock wrote *Nightmare Abbey*, while down the road in Marlow, his close friend Mary Shelley was writing *Frankenstein*. J. H. Riddell wrote a ghost story entitled *A Terrible Vengeance* at the same time that H. G. Wells had the Martians attacking Shepperton in *The War of the Worlds*. More recently another Shepperton resident, the writer J. G. Ballard, became associated with the new wave of horror and science fiction with his novels *The Wind from Nowhere*, *The Drowned World*, *Empire of the Sun* and *Unlimited Dream Company*. There is support to purchase Ballard's modest semi in Shepperton and turn it into a museum.

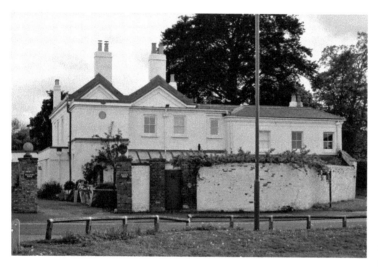

Above left and below left: The former home of Thomas Love Peacock with its blue plaque.

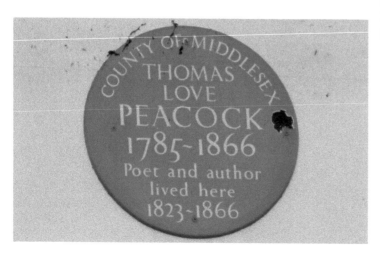

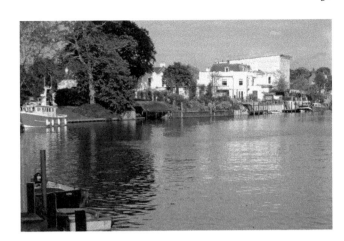

The same houses seen from the river.

Vine Cottage, home of writer George Meredith, friend and associate of other literary figures of the day – James Barrie, Sir Arthur Conan Doyle, Henry James, Robert Louis Stevenson and Oscar Wilde.

The coming of the railways brought in a new influx of Shepperton residents, mainly professional people who saw the advantage of living in Shepperton while working in London. They changed the face of the village entirely because they wanted houses conveniently close to the station, not a mile away in the old village centre. Builders were quick to respond and began buying plots of land to build houses. In 1898, the church sold a large area of glebe land between the station and Old Charlton Road to a local builder named Thomas Lucas, who built fifty or so houses. More were built at the northern end of Highfield Road eastward along Green Lane and Manygate Lane. By 1914, quite a large residential area had developed around the station and Highfield Road became the High Street, with shops reflecting the changing economy and lifestyle of the people. From a population of 1,285 in 1881, 100 years later in 1981 it was 11,770. During the nineteenth century London's rapid growth meant an unprecedented number of bricks were needed to meet building demands, and several brickworks opened in Shepperton. Pug mills were used for compressing prepared clay and cinders to form bricks and speed up the process, enabling approximately 4 million bricks to be produced in Shepperton per year.

DID YOU KNOW?
Shepperton brickmakers prided themselves on their quick production methods but sometimes it was too quick. There are instances where the carts taking the bricks to London would burst into flames because the bricks, packed with straw, had been loaded too soon and were red hot.

With the introduction of the railways for ease of transportation, the brick industry flourished and by 1864 the brick fields occupied quite a large area of land in Lower and Upper Halliford. Land where the brick-earth outcropped was usually rented from a landlord who was paid according to the number of bricks produced. A local brickmaker named William Cattling paid the church £55 12s 4d from the sale of bricks produced from a small piece of glebe land next to Shepperton station. He also bought and worked the land north and south of Green Lane for a decade or two, but as the brick industry went into decline at the time of the Second World War, he sold the land for house building, which totally transformed this area from the 1930s onward.

Another building material in great demand was gravel. Prior to 1914, production was under 2 million cubic yards per annum but by 1938, it had reached 25 million cubic yards per annum. Early gravel extraction was above water level but as this became a commercial operation, deeper gravel pits were dug below the water level. After extraction they were left as lakes for fishing and sailing, which now form a very pleasant feature of the landscape – a mini Lake District on the doorstep of London.

Chalet-style wooden holiday homes began to appear along the riverbank on the former water meadows. Over time, these have become permanent homes and gradually have been modernised and rebuilt. Given their enviable position with river frontage, they are much in demand. The problem is these meadows are on the floodplain and when the water level of the river rises as it did in 2014 and to a lesser extent in 2019, they are likely to flood.

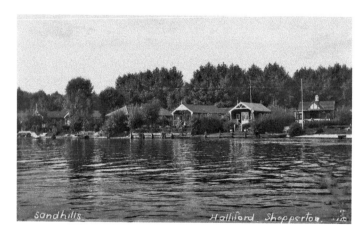

Sandhills Meadow, 1932.

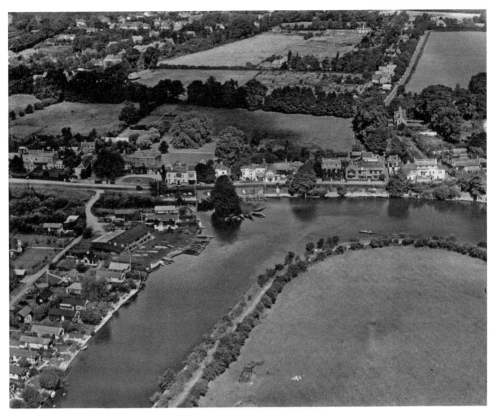

Aerial view of the Halliford Bend in the river. The village of Shepperton is in the top left.

Flooding caused the river to rise over the patio, 2020.

DID YOU KNOW?
Of special architectural interest are the houses built on Manygate Lane in 1964 by the Lyons Group and designed by the Swiss architect Edward Schoolheifer. An article written by Sarah Wise for *The Guardian* in 1999 describes the project as 'a rare British experiment in modernist private-sector housing ... set around traffic-free shared open spaces with extensive landscaping'. The houses have had many well-known residents, including Tom Jones, Marlon Brando, Dickie Valentine, Rod Steiger and Julie Christie.

After the Second World War tastes changed and people no longer travelled from London to enjoy the relaxed riverside facilities. As demand fell, hotels like The Ship closed. It was replaced by a block of apartments. Boat building changed, although repair, mooring and hire is still available from the boatyards along this stretch of the river – Shepperton Marina, Bridge Marina, Walton Marine and Nauticalia.

Above left and below left: Bridge Marina.

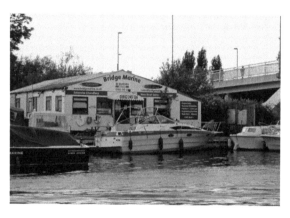

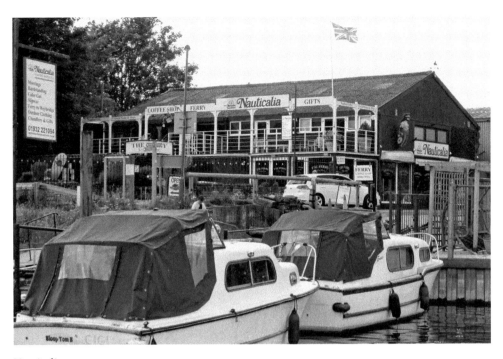

Nauticalia.

The figurehead at Nauticalia.

4. Littleton House and the Birth of Sound City

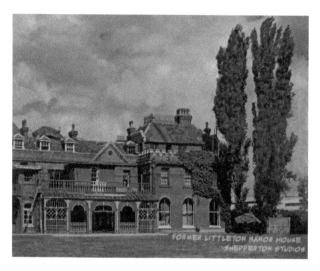

Littleton House.

Coat of arms in the grounds.

Littleton House was one of a series of impressive houses in and around Shepperton. Owned by the Wood family, throughout the nineteenth century the family consolidated its position among the landed gentry by contracting alliances with the aristocracy. Colonel Thomas Wood and his wife enjoyed the friendship of King William IV and Queen Adelaide, and members of the royal family regularly visited Littleton House. The Prince of Wales, later Edward VII, enjoyed its country lifestyle and indulged in his favourite sport of hunting there. Until a few years ago, in the former grounds was a ruined summer house and a toppled urn bearing the inscription 'This urn is placed by Lady Caroline Wood to commemorate the last visit of King William lV to these grounds in 1836.'

The Wood family continued to reside at Littleton House until a disastrous fire in December 1874 destroyed almost half the house, and after a family occupancy of 255 years, the Littleton estate was put up for sale. There were no takers, so between 1892 and 1897, the estate was broken up and eventually in the early 1900s, Littleton House was bought and repaired by Sir Richard Burbridge, managing director of the famous London store Harrods.

DID YOU KNOW?
After the coronation of Edward VII and Queen Alexandra on 9 August 1902, the temporary robing room from Westminster Abbey was re-erected at Littleton House and became known as the Coronation Building. It's a rather fitting tribute to the fact that Edward had spent so much time here. (The Anchor in Church Square acquired its elaborate wooden entrance porch from the same source.)

Fragments of stone balustrading and the ruined bridge in the grounds of Littleton House are a reflection of its former elegance.

It was during this time that Littleton lost most of its area under the Queen Mary reservoir. With the growth of London and the suburbs, water was much in demand and Shepperton was the place chosen to build a storage reservoir. Roads had to be diverted and displaced villagers had to be rehoused, but thanks to Sir Richard Burbidge, one building, Astleham Manor Cottage, was dismantled and saved, and can be seen today at the Chiltern Open Air Museum.

Work began on the reservoir in 1914 but was disrupted by the war and not completed until 1925. On 13 June, it was officially named the Queen Mary Reservoir after the queen consort of the day. With a capacity of 6,700 million gallons, covering an area of 707 acres, a circumference of 4 miles and lying 450 feet (140 m) above the surrounding landscape, at the time it was the largest free-standing reservoir in the world and is still one of the largest reservoirs supplying London with fresh water.

Sir Richard lived at Littleton House until his death in 1917 and is buried in St Mary Magdalene parish churchyard, Littleton. Burbidge Road is named in his honour.

After Sir Richard's death, the 900-acre Littleton estate was sold to Sir Edward Nichol MP, who lived there for ten years. Then on 15 December 1931, Sir Edward Nicholl sold Littleton House, 70 acres of land plus woodland and a stretch of the adjoining River Ash to Norman Loudon for £5,000.

DID YOU KNOW?
In 1931, Littleton House changed from being a private manor house to a film studio. With a capital of £3,500, Norman Loudon entered the mainstream British film industry calling his fledgling company Sound City Film Producing and Recording Studio, a name no doubt chosen to emphasise that this was a market leader when silent films were still wowing audiences in cinemas on both sides of the Atlantic.

Sir Richard Burbidge's tomb in Littleton churchyard.

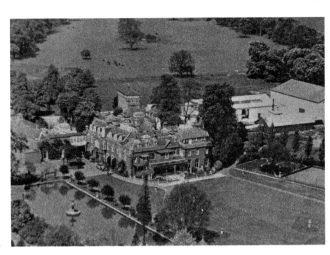

Aerial view of Sound City, 1932.

Norman Loudon was a Scottish accountant who had branched out into producing flicker books for children. Managing director of Camera Scopes Ltd, Loudon's flicker books contained close-up frame by frame pictures of sportsmen that he shot in slow motion with a 35 mm Pathé camera. When fastened into book form, around 2.5 inch x 4 inch, and flicked with a finger or thumb, the images appeared to move showing the sportsmen in action. Each fifty-page book when flicked would give two to three seconds of action, and were very popular at the time.

With no experience of film making, in the industry Loudon was described as a shrewd and resourceful beginner. With a capital of £20,950, much of which was invested by individuals eager to try their hand at film production, the summer of 1932 saw the first tentative steps into film production. Without a stage, early films were shot in the ballroom and conservatory of Littleton House, which became known as the Old House, and by the end of the year Norman Loudon had produced his first seven films.

DID YOU KNOW?
Shepperton studios were equipped with a Visatone Sound-On-Film system that had been developed by Captain Round out of ASDIC submarine detection equipment used during the First World War. The 'Talkies', or talking pictures, had arrived, ending the era of the silent movies.

Throughout 1933, Loudon expanded his production team to include more cameramen, sound recordists and labourers for the carpenter's and plasterer's workshops, and in addition to good personnel, he also shrewdly invested in good equipment. In 1935 Sound City boasted of four cameras, including the then latest compact model, Super Parvo Debrie camera.

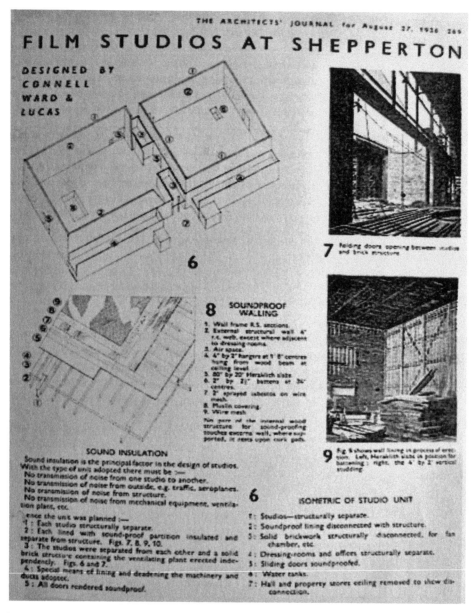

Plans by Connell, Ward and Lucas for the Shepperton Studio, as shown in *Architects Journal*, August 1936.

DID YOU KNOW?
Using the Old House as a hotel with a restaurant for staff and actors, Loudon created a country house atmosphere that was to remain a hallmark of Sound City and its later history. It became known as the studio for the sons of gentlemen.

In 1936, Sound City could offer independent producers seven stages with a total floor area of 73,000 feet, plus a newly built 17,000-square foot concrete pool for exteriors and special effects. Loudon's pioneering spirit and entrepreneurial flair made him a major player in Britain's pre-war film production business, and in 1936 he claimed that 20 per cent of all pictures produced in Britain were made at Sound City, Shepperton. Since 222 films were registered with the Board of Trade that year, Loudon's input would have been at least forty-four films.

His ambitious plans knew no bounds, and in the mid-1930s Loudon decided to build a zoo and pleasure park in the studio grounds alongside his production facilities. Using the skills and artistic ability of the Sound City craftsmen, fifteen differently themed areas were to be created, showing 100 different species of animals and birds against vividly realistic backgrounds of forests, icebergs, tropical rivers and jungles. There was to be a spectacular circus, Noah's Ark and children's paradise with thrills and amusements never before experienced. At the time, the Sound City Zoo and Wonderland would have been the first and only one of its kind. It would be another fifteen years before Walt Disney successfully built his theme parks.

It's interesting that the neighbouring estate of Thorpe Park, just a few miles west of Shepperton, was also undergoing a transformation in the 1930s, when the property was demolished and the grounds excavated for gravel. Forty years later when the gravel pits were expended, the site was flooded to form lakes and in 1975 the Water Ski World Championships were held on the site. In July 1979, Thorpe Park Lake opened to the public and is now one of the major theme parks in Britain.

But back in 1939, Loudon's visionary scheme for a theme park, which was due to open in 1940, was frustrated by the outbreak of the Second World War.

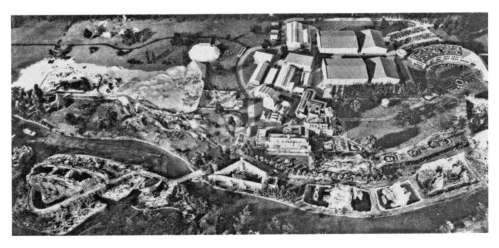

Model of Shepperton's Zoo and Wonderland.

DID YOU KNOW?

In 1940, Shepperton was due to be the location of the first ever theme park and wonderland, fifteen years before Disneyland, which opened in July 1955, and forty years before its neighbour Thorpe Park Resort became the ultimate, exhilarating destination for thrill seekers.

Pre-war Britain was a harsh place for millions of people, and 'the pictures' offered a passport to glamour and a fantasy world far removed from the everyday realities of life at the time. Shepperton studios also offered work for extras – the people who formed the crowds, background movement, buzz of conversation or simply applause. Music halls had a great influence on the films of this period, and a number of popular personalities emerged, including George Formby, Gracie Fields, Jessie Matthews and Will Hay. These stars often made several films a year, and their productions remained important for morale purposes during the Second World War.

DID YOU KNOW?

In 1939, just months before the declaration of war, one of the last films to be made at Sound City was *Spy for a Day*. During filming the phoney war, some of the extras, dressed in German uniforms, nonchalantly strolled down Shepperton High Street causing mass panic.

5. Secret Wartime Shepperton

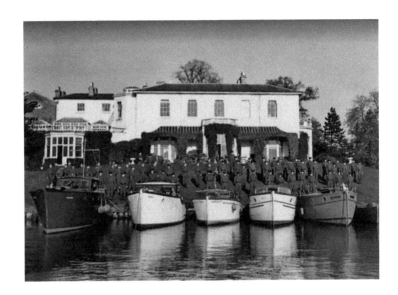

Local men ready for action.

During the Second World War, the people of Shepperton faced the same problems as everyone else in Britain: wartime shortages, rationing, call-ups and the constant threat of enemy attack. Living on the river also brought other problems. Barrages were placed on the straight sections of the river and in some places, like the stretch between Hampton and Sunbury, barges were moored in a line down the centre of the river to prevent enemy sea planes or gliders landing. Members of the Home Guard were often part of the Upper Thames Patrol, who used their own boats to cruise the river at night checking for any unaccountable or suspicious activity. It was a law that anyone who owned a dinghy had to take the oars out every evening before dusk to prevent it being used for clandestine purposes.

Along the river from Hampton to Shepperton there are large reservoirs on both banks supplying water to London. If the enemy had been able to breach these, the result would have been disastrous as we know from the destruction caused when dams in the Ruhr Valley were breached, destroying Germany's industrial heartland. The famous 1955 film *The Dam busters* tells the story. There were gun emplacements by the locks and although they probably helped prevent large-scale destruction of the water supplies, they did not prevent the lock keeper's house on Shepperton's Lock Island being destroyed by a bomb when it took a direct hit. Now there is just one house on Lock Island, the lock keeper's cottage built in 1900 for the foreman of the Conservator's depot, which at that time was located on the island.

The lock keepers' cottage on Lock Island.

Shepperton also had another link with the destruction of the dams in the Ruhr Valley. Working at the Vicker's Armstrong factory across the river at Brooklands, Weybridge, was Barnes Wallis, the inventor of the bouncing bomb that caused the destruction, and his secretary was Amy Constance Gentry. Amy spent many happy family holidays on Hamhough Island, Shepperton, and it was there that she got her first serious experience of racing light boats. In 1925, she was a member of a club team that defeated crews from France, Belgium and the Netherlands at a royal charity regatta in Brussels. She rowed with her brother Frank in mixed double sculling events and they won three consecutive championships from 1924 to 1926. She went on to become British single sculls champion in 1932, 1933 and 1934, and retired undefeated. She also helped administer the sport of rowing, acting as secretary of the Women's Amateur Rowing Association between 1926 and 1938.

When war was declared in September 1939, Amy was working at Vickers-Armstrong as secretary to Barnes Wallis and assisted him with his famous experiments to make a bouncing bomb to destroy German dams in the Ruhr Valley. Barnes Wallis would practice the principle of the bouncing bomb on the shallow, 10-acre lake in the grounds of Silvermere, Surrey. While trying to perfect the technique, he would catapult wooden models across the water and Amy would row out to retrieve them.

After the war, Amy returned to women's rowing. She coached a new generation to winning form, chaired the Women's Amateur Rowing Association, gave more than fifty

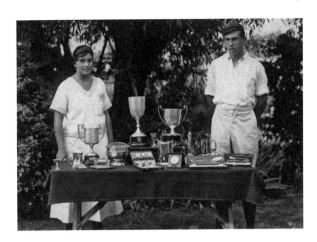

Amy Gentry OBE and her brother
with their many trophies.

Weybridge ladies amateur
rowing club.

years of dedicated voluntary service to the sport, and was awarded the Order of the
British Empire for services to rowing in 1969. She petitioned tirelessly for the inclusion of
women's rowing at the Olympic Games, which was finally achieved in 1976, only a month
after her death.

DID YOU KNOW?
In 1943, during the Second World War, Queen Mary Reservoir, beside Shepperton
Studios, was used for operation Sleeping Beauty, the testing of motorised
submersible canoes built by Special Operations Executives. These underwater
vehicles were designed for a single frogman to perform clandestine reconnaissance
or attacks against enemy vehicles. In 2010, Prince Philip visited the reservoir to
unveil a modern replica of the submersibles tested here. The model is now on
display at the Eden Camp Museum near Malton, North Yorkshire.

Explosive Film

The story of Shepperton has been inexplicably linked with the activity at the studio, yet for many years only a few people knew that Shepperton faced the ever-present risk of a titanic explosion of monumental significance. This was even more threatening during the war years when a stray bomb could have activated it. During this time, GB News had vaults in the grounds of Sound City and some of the early library footage was stored there. These silent newsreels were cellulose treated with sulfuric acid and potassium nitrate to give cellulose mononitrate known commercially as celluloid. It was first used as a base for photographic roll film by George Eastman in 1889 and continued in use for photographic and professional 35 mm motion picture film until the 1950s. But celluloid is not only highly flammable, it also decomposes with age, becoming toxic, and much of the early film footage at Shepperton was decomposing into liquid goo. In this extremely dangerous state the cellulose nitrate film could have caught fire and exploded very easily, destroying not only Sound City but a sizeable amount of Shepperton too. This was an ongoing problem because the high fire risk and combustible qualities of nitrate film increased as it aged and once alight it would have been very difficult to extinguish. In order to avoid this, the priceless early newsreels had to be destroyed permanently and safely. They were moved to a place in Southall where a machine boiled off what was left of the emulsion and extracted the silver content.

The material used to make early films was highly flammable and could have blown Shepperton sky high.

DID YOU KNOW?
Shepperton could have been blown sky high at any time because of a highly flammable material called celluloid that was used as a base for the early films that were stored at the studio.

In 1939, British film production was about to hit an inevitable slump. Small-scale filming continued at Shepperton with the production of the government's own propaganda films but filming was often disrupted by German bombers because of the studio's close proximity to the Vickers-Armstrong aircraft factory at Weybridge. Due to wartime shortages of material, staff and film, more than half the studio space was taken over for other purposes better suited to the conflict.

DID YOU KNOW?
The Ministry of Defence used stages A, B, C and D to store sugar for manufacturers Tate and Lyle, but when the Vickers-Armstrong aircraft factory was bombed and badly damaged, the sugar was removed and replaced by Vicker's workers, who made Wellington bomber parts and spares at the studios.

Several times the studios came under attack without loss of life. A bomb lodged under D stage and the Royal Engineers were called in to dig it out, but on 21 October 1940 during a German air raid, a bomb fell on C stage roof, bounced to the ground and exploded, killing two boys who were sheltering in a corner. A simple plaque commemorating this tragedy can be seen in Littleton Church. On 23 February 1944, nine people were killed, including nurse May Durrell, who refused to use the shelter in case she was needed elsewhere. Durrell Way in Shepperton is a tribute to her courage.

The Dunkirk Little Ships

What is not so obvious is the part that Shepperton took in May/June 1940 at the relief of Dunkirk in northern France. 336,000 British, French and Allied soldiers had been cut off from their advance into France by the German army and were trapped on the beaches of Dunkirk, subjected to constant bombardment. Because of the shallow waters, British destroyers were unable to approach the beaches and soldiers were trying to wade out to the boats, many of them waiting hours in shoulder-deep water. Britain was faced with the seemingly impossible task of rescuing one third of a million men, but help was at hand with Operation Dynamo. On 27 May, the small-craft section of the British Ministry of Shipping telephoned boat builders in the south, asking them to collect all boats with low draft that could navigate the shallow waters. Most of these were pleasure boats, private yachts and launches moored on and around the River Thames, and within hours many boats were taken from their riverside moorings. Some were requisitioned by the government with no time for the owners to be contacted, others were taken with the owners' permission and with the owners and experienced volunteers sailing them.

The boats from the Shepperton stretch of the river were taken to Tough's Boatyard in Teddington. There the elegant motor yachts, ranging in size down to as small as 25 feet, were stripped of their peace-time finery. Bedding, furniture and fittings were carefully

stored ashore, the engines checked over, and the fuel tanks filled. They were then made up into 'trots' of twenty vessels and more, and towed by Tough's steam tugs to Sheerness, Ramsgate or Dover where the navy took command.

Between 26 May and 4 June 1940, their role became crucial. They were the ferries that lifted the waiting troops off the beaches, grounding their bows on the hard sand, and using kedge anchors to draw off as the men scrambled aboard. Then with every cubic foot of space crammed with exhausted humanity, while some of the boats acted as shuttles ferrying soldiers to the warships restricted to the deep water offshore, others each carried hundreds of soldiers back to Ramsgate, protected by the Royal Air Force from the overhead attacks of the Luftwaffe. In nine days, 192,226 British and 139,000 French soldiers – more than 331,000 total – were rescued by the 700 little ships and around 220 warships. The rescue operation turned a military disaster into a story of heroism, which served to raise the morale of the British. It was in describing the success of the operation that Churchill made his famous 'we shall fight on the beaches' speech. The phrase Dunkirk spirit is still used to describe courage and solidarity in adversity.

DID YOU KNOW?
Between May and June 1940, Shepperton's little boats played a crucial part in rescuing one third of a million men from the beaches of Dunkirk, and now every year those little boats that earned their place in British history sail ceremoniously up the Thames to Weybridge Mariner's Club on Lock Island, Shepperton. There the Dunkirk survivors – men and ships – are welcomed by the Commodore and enjoy the club's hospitality.

 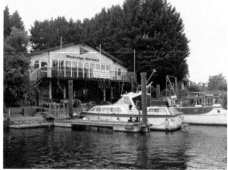

Left and right: The Little Ships annually sail up the Thames to Weybridge Mariner's Club on Lock Island, Shepperton.

Shepperton's Sound City Studio Was Part of the Wartime Secret Service

During the war, Britain's secret service used the film industry to move people around from one country to another to act as spies. One of Sir Winston Churchill's personal agents was a Canadian named William Stephenson, who pre-war had invested in Sound City. In 1940 Stephenson was chosen to set up the secret intelligence centre in America, which initially operated clandestinely from the Rockefeller Centre in New York. Known as British Security Co-ordination (BSC), it grew into a major intelligence force helped by some of the film industry's biggest names.

DID YOU KNOW?
Film directors were hired to make propaganda films, actors gave acting lessons to secret agents, and top make-up artists helped agents with disguises.

Among the pilots who flew for Stephenson was star of pre-war films Captain Hughie Green, who later found fame as a popular TV host on talent shows such as *Opportunity Knocks*. Noel Coward was one of Stephenson's spies. 'My celebrity value was a wonderful cover. No one ever issued me with a false beard. My disguise was my own reputation as a bit of an idiot,' he confessed on the eve of his death in 1973. Greta Garbo was one of Stephenson's agents. Through her contacts in her native Sweden, which remained neutral, she was able to supply Stephenson with information on German spies in Stockholm, set up escape routes for Allied escapees from occupied Europe and order vital supplies from this officially neutral country. Many personalities of the day became celebrity agents during the war: J. B. Priestly, Virginia Woolf, Noel Coward, Jacques Cousteau, Malcolm Muggeridge, Roald Dahl, Graham Green, John le Carré, Dennis Wheatley, Benn Levy and David Niven.

DID YOU KNOW?
Greta Garbo and Noel Coward were among a host of celebrities who worked undercover as spies for British Security Co-ordination during the Second World War, but film heart-throb Errol Flynn (1909–59), who set the gold standard for celebrity debauchery with his drinking, fighting and fooling around, was accused of being a Nazi spy according to biographer Charles Higham.

Sir Alexander Korda

Sir Alexander Korda, who would later take over Sound City, was another of Stephenson's spies. Born in Hungary where he began his career, he worked briefly in the Austrian and

German film industries before moving to Hollywood for the first of two brief periods there. The second period was during the war when he helped build Camp X, a training centre west of Toronto where espionage agents were given coaching for missions in occupied Europe. Korda knew Europe well and studied plans and photographs before recreating German locations for exercises. He scoured film vaults for clips that would familiarise spies with their European destinations. He allowed his New York office in the Empire State Building to be used as a clearing house for intelligence information, and between 1935 and 1945, he made twenty four Atlantic crossings acting as a secret courier between Britain and America. But Korda's activities did not go unnoticed by the Germans, and as a Jew, he was on the Gestapo arrest list. On 22 September 1942, Alexander Korda was knighted at an investiture ceremony at Buckingham Palace by George VI for his contribution to the war effort, the first film director to receive the honour.

Visual Deceptions Were Produced at Shepperton's Sound City Studios

Shepperton studio's greatest contribution to the war effort was in visual deception. Sound City employed some of the finest craftsmen in the industry to produce fantasy worlds, so who better to produce dummy weapons, buildings and decoy airfields designed to fool the enemy. Colonel Sir John F. Turner was given the responsibility for supervising these measures and established his department at the Shepperton studio. When America entered the war in 1941, the guns of an anti-aircraft site at Addlestone, a stone's throw from the studio, were taken to help defend New York and were replaced by dummy guns made at the studio? From a design by Professor Basil Spence, one of Britain's leading architects, the craftsmen at Shepperton built a giant oil storage and docking area stretching several miles along the shoreline near Dover. Guarded by police, the whole facility was a fraud but it fooled the enemy into thinking it was the terminus of an underwater pipeline that would eventually extend to Calais, heralding an imminent invasion in that area.

The dexterity of its skilled craftsmen was not just limited to work at the studio. As Captain Proud, Sound City's Art Director Peter Proud was located at Tobruk, North Africa, where he was responsible for protecting the garrison's drinking supply. He used his creative talents to fool the enemy by creating the illusion of a wreckage. Small bomb craters were dug among the buildings then accentuated with shadows made from oil or coal dust. The roofs of the main works were camouflaged with canvas, paint and cement to resemble mass damage and destruction, while debris was strategically scattered over the rest of the area. The ruse worked.

DID YOU KNOW?
The studio's skilled artists and craftsmen used their creative talents to create illusions and camouflage to confuse the enemy.

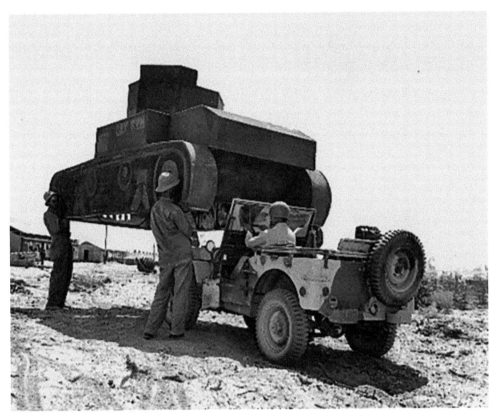

A dummy tank, so light it could be lifted by a couple of men.

We know much about this camouflage work through books about Jasper Maskelyne, a successful stage magician. In his book *Magic: Top Secret*, published in 1949, he states that a lifetime of hiding things on the stage had taught him more about camouflage than others would ever know, so when war broke out in 1939, he joined the Royal Engineers Camouflage and Experimental Section. He claimed to have convinced skeptical officers by creating the illusion of a German warship on the Thames using mirrors and a model. In 1940, he underwent training in the arts of military camouflage alongside artists such as Roland Penrose, Stanley William Hayter and Julian Trevelyan to be a camoufleur at the Camouflage Development and Training Centre at Farnham Castle. They were taught to create small devices intended to assist soldiers to escape if captured. These included tools hidden in cricket bats, saw blades inside combs, and small maps on objects such as playing cards. Brigadier Dudley Clarke, the head of the 'A' Force deception department, recruited Maskelyne, who was briefly a member of Camouflage Experimental Section before being transferred to welfare then back to entertaining the soldiers with magic tricks.

Yet there are several books written about Maskelyne's exploits in which he makes lurid and extravagant claims of cities disappearing, armies relocating, dummies proliferating and the supposed concealment of the Suez Canal, all as a result of his knowledge of the magic arts. Apparently, he and his team hid naval harbours, launched a fleet of

258-feet-long dummy submarines and built a 700-feet-long battleship. They produced dummy men, dummy steel helmets, dummy guns by the ten thousand, dummy tanks, dummy shell flashes by the million, dummy aircraft. If you believe this colourful account of the ingenious way he could fool the enemy, the flamboyant magician's contribution was absolutely central to the war effort, but official records and more recent research show that Maskelyne's contribution was marginal and his stories in the most part pure invention. That's not to say such things were not produced and executed, but not necessarily by Maskelyne. It's more likely that Brigadier Dudley Clarke, the head of the 'A' Force deception department, encouraged this vain grandiose member of the Second World War desert camouflage unit to take credit, as cover for the true inventors and people who implemented the dummies. Such tales also encouraged confidence in these techniques among Allied high command.

But the myths about Jasper Maskelyne's exploits continued, so what could be more fitting than to make a film based on his life. The film director Peter Weir with actor Tom Cruise were working on the film when it became apparent that the stories about Maskelyne in the book *The War Magician* were without enough factual basis to proceed. Although large sums of money had been spent in pre-production, the film project was dropped, yet the story still continues to attract attention as a movie subject. In 2015 Benedict Cumberbatch was reported as signing on to play the role, provided a director could be found. Whether Jasper Maskelyn's exploits are true or false, this is a story the likes of which should be made and dedicated to those remarkably talents inventors and artists whose contribution was central to the war effort. Their secret activity deserves our respect.

Secrets of the Normandy Landings – The Biggest Single Hoax of the War, Activated by Shepperton Sound City's Ingenious Craftsmen and Women

In 1943, plans got underway to accomplish the Normandy landings, often referred to as the D-Day landings, the largest seaborne invasion in history. In the months leading up to the invasion, the allies conducted a substantial military deception codenamed *Operation Bodyguard* to mislead the Germans as to the date and location of the main Allied landings. To make such a large-scale attack seem possible, they relied upon false leaked information, faked operations and fictional field armies. They also needed to increase the apparent size of the Allied forces and one of the ways of doing this was to create mock hardware.

The practice of using mock tanks and other military hardware had been developed during the North Africa campaign for the attack at El Alamein, but for *Operation Bodyguard* the Allies wanted deception in the form of dummy landing craft. To support this deception, Sound City designers built hundreds of dummy landing barges made of canvas and wood that floated on empty oil drums. They were assembled in the First United States Army Group (FUSAG) staging area where vehicles and supplies were stockpiled in readiness for what was believed to be embarkation to Calais. But FUSAG was a totally fictional army and this deception delayed the German Army in the Pas de Calais for seven weeks, allowing the Allies to build a beachhead and ultimately win the Battle of Normandy. The operation began the liberation of German-occupied France

and later western Europe, and laid the foundations of the Allied victory on the Western front. In his memoirs, General Omar Bradley, senior American officer during the war, called *Operation Bodyguard* the single biggest hoax of the war, so it could be said that Shepperton Sound City's craftsmen and women played a very substantial part in the success of the D-Day landings.

DID YOU KNOW?
In order to confuse the enemy into thinking the D-Day landing would take place at Calais, Sound City designers built hundreds of dummy landing barges made of canvas and wood that floated on empty oil drums. *Operation Bodyguard* was the single biggest hoax of the war.

During Warship Week in March 1942, the people of Shepperton contributed £55,000 to adopt the Net Class Boom Defence Vessel HMS *Sonnet*. With its crew of thirty-two, its primary function was to lay and maintain steel anti-torpedo or anti-submarine nets around an individual ship at anchor, or around harbours or other anchorages. HMS *Sonnet*'s Battle Honours included service at the Allied invasion of Normandy in June 1944 laying moorings and buoys for the Milberry Harbour at Arromanche. The Milberry harbours were temporary prefabricated harbours taken in sections across the English Channel to facilitate the rapid offloading of troops and cargo onto beaches during the Allied invasion of Normandy. HMS *Sonnet* was scrapped in 1959 in Holland but the ship's bell now hangs in Shepperton library.

The ship's bell from HMS *Sonnet*.

Dad's Army was filmed at Shepperton and at nearby locations.

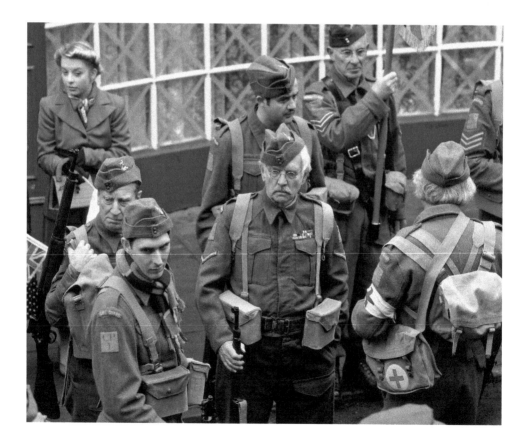

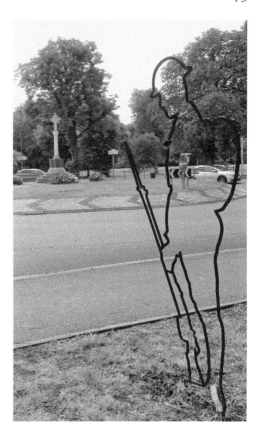

Shepperton's war memorial and commemorative statue.

Dad's Army is a 1971 British war comedy film and the first film adaptation of the BBC television sitcom of the same name. Directed by Norman Cohen, it was filmed between series three and four and was based upon material from the early episodes of the television series. The film tells the story of the Home Guard platoon's formation and their subsequent endeavours at training exercises. Made partly at Shepperton and partly on location, before its recent revamp, the interior of the Bell Inn on the Old Charlton Road, less than a mile from Shepperton studio, was used for filming.

Although weekly attendance at cinemas had peaked during the war to 31 million, it dropped again in 1945. The British film industry was supplying only 20 per cent of the footage shown in British cinemas, and like many industries, it was finding rehabilitation a slow and difficult process after the war. Government departments were reluctant to hand back the studios, poor quality celluloid film often needed to be constantly repaired, and treasury officials were reluctant to grant permits for what they considered to be non-essential film imports. Despite all the setbacks Norman Loudon announced that Sound City would open again in September 1945 with the making of *London Town*, Britain's answer to a Hollywood musical. Even as the film was being shot, on a neighbouring stage, broken down wartime aeroplanes were being patched up, and sadly this pseudo-Hollywood epic was doomed from the start.

6. Seventy-Five Years at Shepperton Studios

In 1945, Norman Loudon, who had been the driving force behind the creation of the Shepperton Sound City, had had enough. He quietly relinquished control and vanished from British film production.

Sir Alexander Korda (the wartime secret agent knighted for his services) acquired 74 per cent controlling interest over Sound City and in 1946 renamed it the British Lion Studio Company. At the end of the war, the country was virtually bankrupt yet under Alexander Korda, there was reason to think that 1947 would be the beginning of an exciting new British film industry. However, there were a few hitches. Korda's first film at Shepperton was *Bonnie Prince Charlie*, which took thirty shooting weeks to complete, easily one of the longest British shooting schedules at the time.

> DID YOU KNOW?
> The filming of *The First Gentleman* (1947) went alarmingly over budget due to the genuine antique furniture that was ordered for the sets.

The average seat price was 1s 6d (7.5p) and box office takings had peaked at £121 million, providing the exchequer with £41 million in entertainment tax, but American films occupied 80 per cent of screen time in British cinemas and the government was looking for ways to save payment to American companies. In August 1947 they imposed a custom duty of 75 per cent on the value of all imported films and the American reaction was immediate – all further shipments of films to Britain would stop immediately. Although British film producers had lost the main competition, the industry was in serious trouble and faced imminent collapse because they were not able to meet the demand until on 11 March 1948, the Anglo/American film industry reached an agreement.

British Lion Studio Company based at Shepperton was the second largest production/distribution company in the country, yet it had suffered such severe production losses that the company was in a perilous state and on the verge of bankruptcy. If British Lion was allowed to collapse the rest of the industry was likely to follow, but pleas to City investors fell on deaf ears. It was left to the government to intervene, providing a £3-million loan at 4 per cent interest through the National Film Finance Corporation (the NFFC), but it was too little, too late as £1 million went immediately to pay off their creditors.

Shepperton Studios.

DID YOU KNOW?
There's a lovely story dating from 1949 when *The Third Man* was shot at Shepperton and on location in Vienna. Anton Karas, an unknown forty-year-old German musician, composed the zither music which became known as the Third Man Theme tune. An unprecedented number of records were sold in Britain within weeks of the film's release, and in the United States, it spent eleven weeks at number one. However, during filming at Shepperton, Guy Hamilton, the assistant director on the film, took Anton Karas to the King's Head in Church Square for a drink and Karas produced his zither. He began to strum the vibrating strings of the instrument, playing the distinctive music from the film, but the locals were not impressed and told him in no uncertain terms, to pack it in.

Only a few years after receiving money from the NFFC, British Lion could not meet their commitments and the government decided to call in the loan. British Lion Studio Company went into receivership on 1 July 1954 and in January 1955, a new company, British Lion Films Ltd, was formed. To kick start it, the government put in £600,000 of public money. Commercial TV was launched in September 1955 and alongside the

growing importance of television production came the filming of TV commercials, but tragically Sir Alexander Korda died of a heart attack in January 1956.

Film Snippets

Well into the 1950s, most actors' extracurricular activities stayed off the public's radar, yet even almost fifty years after his death, many of us are familiar with the name Charlie Chaplin. His onscreen persona as the Little Tramp, the man with a toothbrush mustache, bowler hat, a cane, and a funny walk entertained audiences with his slapstick humour. Born in London, his understudy was Stan Laurel, and both moved to America to advance their careers with Fred Karno's troupe. Fred Karno was a talent spotter who later bought Tagg's Island at Hampton, just down the river from Shepperton, and built an impressive hotel on it.

Stan Laurel became better known as the other half of the comic duo Laurel and Hardy, and Charlie Chaplin became a film-maker, but because of alleged Communist sympathies and troubles with the IRS, he was forced to leave America. He was the first film-maker to dare to expose, through satire and ridicule, the paranoia and political intolerance, which overtook the United States in the Cold War years of the 1940s and 1950s. He had been a target, and in 1957, having written *A King in New York*, he produced the film version at Shepperton studios.

Charlie Chaplin, his understudy Stan Laurel and the Fred Karno troupe.

DID YOU KNOW?
Charlie Chaplin claimed shamelessly that he had slept with more than 2,000 women over the course of his life and he is said to have introduced the casting couch method of selection for young starlets. When asked in an interview to describe his ideal women, Chaplin replied 'I am not exactly in love with her, but she is entirely in love with me'. One biographer claimed Nabokov's Lolita was inspired by Chaplin.

Big name stars have always been attracted to Shepperton. In the 1950s Dirk Bogarde's good looks made him the 'Idol of the Odeons' particularly after his success in *Doctor in the House,* but after seeing him in *The Servant*, filmed at Shepperton in 1963, there was the definite question: was he homosexual? Peter Sellers established himself as a master impressionist with the Goon Show and as well as numerous radio and television shows throughout his career, he appeared in over sixty films, sixteen of which were shot at Shepperton, including the infamous Pink Panther films, which in 1963 introduced the world to Seller's best-known character, Inspector Clouseau, the Pink Panther's bumbling master of disguise. At the same time, the viewing public were flocking to see Sean Connery in the James Bond films. This was a winning combination of sex, exotic locations, casual violence and cunning gadgets. The series became a global phenomenon with such spin-offs as *Casino Royale*, filmed at Shepperton in 1967. A wacky send-up of James Bond films, starring David Niven as the iconic debonair spy, *Casino Royale* used every stage at Shepperton for months, for what was described as 'all manner or madness'. The Bond series also led to rival series of more realistic spy films like *The Ipcress File* and *The Spy Who Came in from the Cold*, starring Richard Burton and filmed at Shepperton in 1965. James Bond had been everyone's favourite spy, but this was a more realistic, harsher approach to spying that the public found hard to comprehend.

The post-war generation welcomed a new wave of films known as kitchen sink dramas dealing realistically with sex and abortion. *The L-Shaped Room* (1962), starring Leslie Caron, is about a young French woman who is pregnant and unmarried renting a room in a dingy London boarding house. *The L-shaped Room*, published in 1960, was the first adult novel written by Shepperton resident Lynne Reid Banks, better known now for her The Indian in the Cupboard book series.

Entertainment news continues to grow in our celebrity-obsessed culture but the stars who have travelled to, stayed at and made their homes in Shepperton are too numerous to include here. One exception must be Elizabeth Taylor, the last of the classic movie legends and a template for the modern celebrity.

Elizabeth was no stranger to Shepperton. In 1959 she filmed *Suddenly Last Summer* at Shepperton studios and in the first heady days of her relationship with Richard Burton who was filming *Becket* at Shepperton studios in 1964, Elizabeth was regularly on set watching proceedings and could be found drinking in the Shepperton pubs with Richard Burton and Peter O'Toole.

Elizabeth Taylor and Richard Burton were regulars in Shepperton pubs.

DID YOU KNOW?
Richard Burton and Elizabeth Taylor stayed in Shepperton during the filming of *Becket* and it was here that one of the most famous love stories of the twentieth century blossomed. According to the receptionist at The Anchor in Church Square where they were staying, they didn't leave their room for four days.

The Anchor became a popular haunt for celebrities from the studios in the post-war years, many of whom lived in Shepperton. There's a long list but because it's necessary to limit word count, this must be restricted to just a few. These included Bernard Braden and Barbara Kelley, who lived at Creek House. When they left, John Gregson moved in until his untimely death. Frank Finlay, Sandra Dickinson, Tom Jones, Marlon Brando, Dickie Valentine, Rod Steiger, Julie Christie and Kate Winslet were all former Shepperton residents. Between 1969 and 1978, the Barn Bar at the Ship Inn (now demolished) held nightly and Sunday lunchtime discos that were a popular venue with the likes of the members of Mungo Jerry, The Jam and The Faces, who lived locally. The band Mungo Jerry was founded by Raymond Edward Dorset, guitarist, singer and songwriter best known for his hit single 'In the Summertime', which after forty-seven years is still the sound of the summer.

But not all the celebrity residents were actors or musicians. One notorious, short-term resident hiding out in Shepperton was train robber Ronald Buster Evans. He was part of a gang that on 8 August 1963 held up the Glasgow–Euston mail train in Buckinghamshire, and escaped with £2.3 million in used banknotes – equivalent to over £50 million today. All the newspapers carried the story and photos of the three ring leaders, Ronnie Biggs, Bruce Reynold and Ronald Buster Evans. With £10,000 reward being offered for information, soon Shepperton sleuths realised that the family going by the name Green, living at No. 6 Old Forge Crescent, just off Shepperton High Street, were in fact Ronald Buster Evans, his wife June and their two-year-old daughter Nicolette. Police officers arrived from Hampton on 1 September, but the house was deserted. Buster Evans and

CATALOGUE

OF THE

FILM STUDIO EQUIPMENT

AT

FILM STUDIOS, SHEPPERTON, MIDDLESEX

FOR SALE BY AUCTION

ON

MONDAY 30th SEPTEMBER 1974

And Following Days at 10-30 a.m. precisely each day

On View: From 16th September 1974, Monday to Friday from 9-30 a.m. to 4-30 p.m.
(On Wednesday & Thursday 25th & 26th viewing will be extended until 7-30 p.m.)

AUCTIONEERS:

FULLER, HORSEY, SONS & CASSELL

IN CONJUNCTION WITH

EDWARD RUSHTON SON & KENYON

Front page of the catalogue.

Bentley reassessed the situation and in January 1973 he sold out to J. H. Vavasseur & Co. but very soon they were in danger of crashing. No other company was interested in purchasing the ailing film company so Vavasseur's answer was to clear out the studio equipment and props at a five-day auction held at the studio. Beginning on 30 September 1974, over 3,000 lots were listed in a 168-page catalogue.

DID YOU KNOW?
Bobby Murrell, Shepperton's long-serving props man, claimed that the begging bowl used by Oliver in the film of the same name had been under his bed since 1968 (don't ask why), but at the time of the auction, some twenty other begging bowls were also in circulation. Murrell's bowl fetched £28.

In November 1974, a new-look Shepperton Studio Centre was officially launched with upgraded facilities and infrastructure. Although film production was high, management continued to insist that the studio was operating at a critical loss. By March 1975 outline planning permission had been granted for 253 houses, 234 garages and 237 parking spaces to be built on former studio land and in June 1975, it was reported that Lion International was selling its remaining interest in feature film production and distribution to Headhome. A year later, producer Harry Saltzman, who had amassed a fortune from his co-production of the James Bond films, made a bid, estimated to be £8 million, for the entire 60-acre site. Others like Ladbrokes, the bookmaking and hotel group, and the entertainment company Pleasurama were also interested but their attempts all failed.

On 25 August 1976 EMI bought British Lion Ltd and retained the name. A deal was agreed between the studio and Spelthorne Council for the council to purchase 14 acres of the studio site, including the main entrance area, for housing and a further 20 acres for open space amenities. They paid £473,000 for what had previously been studio land, and it became a housing estate.

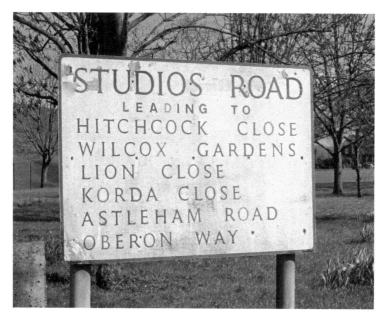

Roads that were once on land belonging to Shepperton Studio have the names Hitchcock Close, Korda Close, Lion Close, Oberon Way and Wilcox Gardens.

Houses built on former studio land show how close they are.

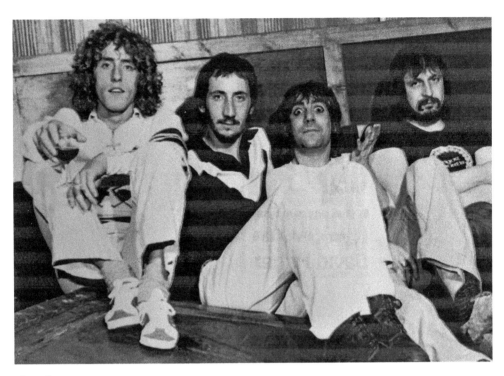

The Who.

The studio was left with an area of approximately 26 acres and a further 5 acres on lease. On 1 July 1977, Rampart Enterprises – the holding company of pop group The Who with Roger Daltry, Pete Townshead, John Entwhistle and Keith Moon – leased 6 acres of the studio, including the Old House (the former Littleton House) on a 999-year term. They paid £350,000 with an option to purchase the freehold for £1 but surrendered the lease on 9 July 1981.

DID YOU KNOW?
Pop group The Who filmed live concert scenes at Shepperton especially for their documentary *The Kids Are Alright* (1979). It would be the band's final live performance; drummer Keith Moon died later that year.

Over the next few years the studio operated rather precariously. In October 1980, the agreement between the studio and Spelthorne Council was modified and in May 1981, a further exchange of land with the council saw outline planning permission given for new buildings on the site, plus space for 907 cars and three trucks. By 1981, the studio was being used for TV, as well as film production, and taking effect from 12 May 1982, a special resolution was passed for Shepperton Studios Ltd to be registered as a private company.

DID YOU KNOW?
Not all the action was at the studio. On 21 April 1982, as the Waterloo to Shepperton train was pulling into Shepperton station, the brakes failed and it crashed into the buffers 100 yards past the end of the platform. No one was injured.

On 16 August 1984, Shepperton Studios Ltd was acquired by Lee Electric Lighting Ltd, who had been tenants since 1974. Over the next thirteen years they gradually acquired the entire 26-acre site for £5.2 million and introduced a massive £15 million refurbishment programme to streamline facilities. The infrastructure was visually improved, new workshops and stages were introduced to blend in with the existing buildings and the entire complex was rewired.

DID YOU KNOW?
In 1985, Sidney Pollack directed the film *Out of Africa*, but when filming had finished, either accidentally or on purpose, many of the exotic birds were released. Thirty odd years later, the vibrantly coloured cockatoos are a regular sight flying round Shepperton.

The list of acquisitions of Shepperton Studios Ltd was also growing and the icing on the cake was the acquisition of Panavision, the market leader in innovative widescreen lenses and advance technology cameras. The enlarged Lee Group had borrowed heavily and they were flying high but the commercial reality of the situation was about to hit. On 19 October 1987, only days after they completed the acquisition of Panavision, the aptly named Black Monday rocked the city as the Stock Market crashed. The Lee Group was in breach of the various banking covenants and in December 1988, American investment bankers Warburg Pincus acquired the Lee Group as collateral for loans taken out by Lee International for a disastrous expansionist escapade.

Shepperton studio was once again in a net of uncertainty and threatened with extinction, but the bank lost no time in restructuring the group and for the next few years, Shepperton Studio was owned by banks. They appreciated the value of this asset and the importance of the studio within the British and International Film Industry, and during this time, production at Shepperton continued steadily with an average of six films produced each year.

DID YOU KNOW?

In 1994, *The Madness of King George,* the film version of the deteriorating mental state of the king was made at Shepperton. The sets for the House of Lords and the king's apartment were made by Shepperton's talented artists but they were not soundproofed. There were a few anxious moments when they were filming intimate scenes in the king's bedroom and trucks roared past outside. The film was a great success, and the sets by Ken Adams won a well-deserved Oscar.

Shepperton's craftspeople were thrown a further challenge when another monarch was the subject of *Elizabeth,* filmed at Shepperton in 1997. Authentic period sets were required, but each of the sets was used two or three times. For example, Queen Mary's death chamber was revamped as Queen Elizabeth's bedroom, which was then revamped as one of her courtrooms.

Throughout this period, production emphasis moved to television and Shepperton built smaller stages to make films for Scottish TV, BBC and Central TV. In 1995, the studios were purchased by a consortium headed by Ridley and Tony Scott, which led to an extensive renovation of the studios, as well as the expansion and improvement of its grounds. They could do nothing about the land previously sold for housing development but they acquired Littleton Park Nurseries, some 8 hectares on which they obtained planning permission in February 2001 to use for exterior filming

Former driveway to Littleton House allows access from the backlot to the studios.

and extra parking. They could do nothing about the River Ash corridor (owned by Spelthorne Council) that runs diagonally through the centre of the site north-west to south-east, but a Deed of Easement was agreed between Shepperton studios and Spelthorne Council to permit the transit of people and 7.5-ton vehicles between the studio compound and the former nursery land. This is via a light vehicular bridge over the River Ash, following the line of the original driveway to Littleton House, an area still scattered with remnants of a designed landscape and broken architectural features formerly associated with Littleton House and Park.

The efforts of the Scott brothers were applauded by many in the film industry. This sale had been a genuine attempt to raise Shepperton's profile and put it back where it belonged among the top studios of the world.

River Ash corridor runs through the centre of studio land.

Above left and above right:
Warning signs.

DID YOU KNOW?
In 1998, *Shakespeare in Love,* the period drama starring Gwyneth Paltrow, Joseph Fiennes and Dame Judy Dench, was shot at Shepperton. Set in 1585–1592 most of the scenery including a reconstruction of the old St Paul's Cathedral and the Rose Theatre, where Shakespeare's earlier plays were performed, were constructed by the talented artists at Shepperton studio. After filming, the Rose Theatre, including dismantled oak timbers, was given as a gift to Dame Judi Dench, who won an Oscar and a Bafta for best supporting actress as Queen Elizabeth I in the film. The actress, who was born in York, has donated the set to the touring British Shakespeare Company to reuse as a working theatre, a permanent Shakespeare centre in the north of England.

The first decade of the twenty-first century was a relatively successful one for Shepperton studios. Thanks to the Scott brothers, the shabby days had gone and Shepperton studios went through a rebirth when on 11 February 2001 a merger with Pinewood was announced and a new company – Pinewood-Shepperton plc – was formed. As well as studios in Britain, the US., Berlin, Toronto, the Dominican Republic and Malaysia, Pinewood now owned part of Shepperton studios in the UK.

Many British films found a wide international audience due to funding from BBC Films, Film 4 and the UK Film Council, and with the launch of Chanel 4 and its Film on Four commissioning strand. The new decade saw a major new film series in the Harry Potter films, beginning with *Harry Potter and the Philosopher's Stone*, filmed at Shepperton in 2001. *Bend It Like Beckham* (2001) was being shot on 'I' stage at Shepperton, while *Gosforth Park* was being shot on another. Shepperton studios were doing their fair share of successfully competing with international productions. After their first major success with *Four Weddings and a Funeral* (1993), Working Title Films scored three major international successes, all filmed at Shepperton and starring Hugh Grant and Colin Firth, with the romantic comedies *Bridget Jones's Diary* (2000), the sequel *Bridget Jones: The Edge of Reason*, and *Love Actually* (2002).

The Shepperton workshops, headed by a construction manager with carpenters, plasterers and painters, created Bridget's London flat, her large open plan office, and her parent's home in the Cotswolds where Bridget suffers her infamous embarrassment as a bunny at the 'tarts & vicars' garden party. Each set had to be dressed by a team of set decorators to get a particular character achieved by such things as locating period wallpaper. *Bridget Jones Diary* made it into the top ten highest grossing films of all times in the UK. Shepperton was used for all the key scenes in *Love Actually* with Shepperton's craftsmen creating the interior sets for No. 10 Downing Street, Heathrow Terminal 5, and the apartment where Mark lived and stored pictures from his art collection.

DID YOU KNOW?

When making *Notting Hill*, a witty romantic comedy with Hugh Grant and Julie Roberts playing the lead characters, crowds of fans flocked to see them on location. It made the production team thankful when they could decamp back to comparative peace of Shepperton. The interior of the Old House was used as the interior of William's house, the Travel Bookshop and Tony's Restaurant. And for their film *Wimbledon*, Working Titles took over the backlot at Shepperton to recreate the centre court at Wimbledon in a completely controlled environment away from the 'maddening crowds'.

When *The Borrowers* was filmed at Shepperton, it threw the artists and artisans an adventurous project. The film is based on Mary Norton's children's story of tiny people who live below the floorboards and survive by borrowing items from a normal-sized

family who live above. It's larger-than-life sets were designed by Gemma Jackson, who said, '*The Borrowers* was probably a designer's dream or potential worst nightmare.' Her remarkably talented team grew with the addition of an army of skilled model makers, sculptors and scenic artists who created two worlds, a normal-sized one and a huge one where the tiny people lived. They created oversized props like a 5-foot washing machine, a 6-foot light bulb and 10-foot action man. The tiny people used cotton reels for seats so when scaled up to seat height each cotton reel was 15 inches high. One borrower falls into a milk bottle that had to be over 20 feet high, and another gets trapped in a fridge with such things as a giant-sized bag of peas, chicken, film wrapped parcels and a large tub of Breyers chocolate ice cream. Computer generated images were used to help create the convincing backgrounds but CGI wasn't as advanced then, and it was expensive, so most things were created by Shepperton's craftspeople.

DID YOU KNOW?
The Shepperton prop makers made the sets for the children's TV series *Thomas & Friends* from 1986 to 2008, after which the live action models originally used were replaced with computer animation.

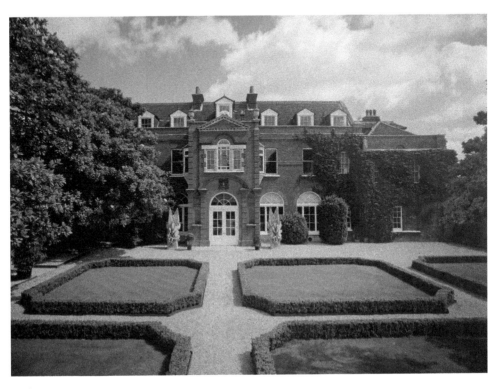

Littleton House.

The original Littleton House, buried in the core of the studio site, has also been used as a filming location. The exterior was used as the school in *Blue Murder at St Trinian's* (1957), and again in *The Great St Trinian's Train Robbery* (1966) while the movies were shot on stage at Shepperton. The Old House and surrounding grounds were used for films such as *The Omen* (1976) and *The Young Victoria* (2009). The interior was used in the 1999 film *Notting Hill*, for the 2001 film *The Mummy Returns,* and in *Batman Begins* (2005). Littleton House has since been bought by Simply Network Solutions and is now a wedding and events venue.

DID YOU KNOW?
The comic drama *Calendar Girls* was shot in Yorkshire and at Shepperton studio and became the surprise hit of 2003. It helped raise the profile of the Women's Institute, who through the sale of 88,000 copies of the Rylstone & District Women's Institute 2000 Nude Calendar raised more than £450,000 to fund cutting edge research into lymphoma and leukaemia at the University of Leeds.

In the summer of 2004, the Scott brothers sold their share in the Pinewood/Shepperton company and it was floated on the London Stock Market. Pinewood-Shepperton submitted a planning application to carry out a major rebuilding programme over ten years intended to increase the amount of square footage of stages and supporting areas by more than 20 per cent. Planning was approved but there were limitations. To the north, the site is bounded by the vast Queen Mary Reservoir, and to the west is a housing estate built on former studio land in 1977. The Scott brothers had acquired Littleton Park Nurseries, which to some extent compensated for the loss of the former backlots lost to housing, yet the former nursery land lies south of the River Ash, which forms a corridor of mature woodland, wetland habitat and open water running diagonally through the centre of the site. Apart from some small-scale demolition, the construction of the John Mills Building (2007) and the Gainsborough Building (2008) most of the other proposals were put on hold and no further changes were carried out.

DID YOU KNOW?
The John Mills building is a fitting tribute to Sir John Mills (1908–2005), a great actor who was no stranger to Shepperton. He started his career in the early 1930s at the same time that Shepperton studio produced its first film.

DID YOU KNOW?
In 2008 when Culture Minister Margaret Hodge visited Shepperton studios to mark the opening of the new Gainsborough Building, she commented, 'Outstanding productions need the best possible facilities, and this important new base for media companies will help ensure that Shepperton Studios continues to make a vital and sustained contribution to the success of our film, TV and commercial sectors.'

In April 2011, The Peel Group acquired a controlling 71 per cent interest in the Pinewood Studios Group for £96 million. The Peel Group is one of the largest property investment companies in the United Kingdom. It owns holdings in infrastructure, land and property, transport, logistics, retail, energy and media. At the end of 2014 Pinewood-Shepperton paid £36.8 million to acquire stakes in the studios and in February 2015, there was a name change from Pinewood Shepperton plc to Pinewood Group plc. In June 2015, The Peel Group reduced its stake in Pinewood Group plc from 58.1 per cent to 39.09 per cent. before announcing in February 2016 that they were considering options including a possible sale. In July 2016, its two largest shareholders, Goodweather Investment Management, owned by The Peel Group and Warren James Holdings agreed to sell their respective holdings to Aermont Capital. Pinewood agreed to the £323 million deal in August 2016, which would take the group private. The sale was completed on 4 October 2016, and the company delisted from the London Stock Exchange the following day. Pinewood is now owned by the PW Real Estate Fund, run by French property investor Leon Bressler.

While such great films as the 2018 film *Mama Mia, Here we Go Again*, a sequel to *Mama Mia*, was being shot on C, D, F and H Stage at Shepperton studios, in February 2018 a major expansion plan that would effectively render all other proposals out of date was announced, and caused quite a controversy. At this point, Shepperton studios occupied 10.5 ha (26 acres) and comprised 80,047 sq m (861,619 sq ft) of floor space in sixty buildings of various ages, sizes and conditions, plus the former Laleham nursery land separated from the main lot by the River Ash corridor. The Pinewood Group had bought 100 acres of previously quarried, adjoining land for the proposed development and was preparing a plan to significantly increase the facilities. In June 2018 management confirmed that they were planning to add the four key components of a typical studio – new sound stages, offices, workshops, backlots with flexible open space for constructing and filming on external sets, and car parking.

Negotiations with local residents and the local council were carried out before a planning application was submitted. The Leader of Spelthorne Borough Council was known to support the studios and welcomed the new plans, but what about the villagers of Shepperton? Resident's opinions were very mixed with more than 130 people objecting to the plans, claiming the expansion would increase traffic and impact on green belt land. The fact that a housing estate is trapped inside the studio perimeter seems to not to have been taken into account. The new expansion plan proposes to build a car park and circular road on a green field site that has always been designated a green belt. As

one resident told *Shepperton Matters* (October 2018, Issue 84): 'They plan to tarmac over this field to create additional parking for the 10% of the time when the studios are at full capacity. They have informed residents that most of the time, this car park will be closed. To urbanise green belt land for the use of an occasional car park seems utterly irresponsible.' The planners replied that 'the landscape strategy is defined within the green-belt infrastructure parameter plan – the details and how this strategy is delivered will be the subject of future reserved matters applications.'

The outline plan for the proposed expansion released in August 2018 shows new development roughly doubling the area of the site. In October 2018, various major production companies including Disney, Lucasfilm, Marvel Studios and Netflix strongly supported the expansion, stating that they would certainly make use of the increased studio space. It's estimated that the studio's expansion would create 2,000 permanent jobs and an annual productivity boost of more than £141 million to the UK economy. This would help the government's ambition to double film and high-end TV investment to the UK from £2 billion in 2017 to £4 billion by 2025.

Shepperton studio has always been a leading UK destination for the production of major films but it faces increasing competition from emerging new facilities in other countries. It's been constrained by the capacity of the existing facilities described as 'a series of fenced off aircraft hangars in some very crowded side streets'. That doesn't stop Hollywood's greats flocking to this unassuming corner of Shepperton to make first-class movies, but refurbishment and expansion are vital to secure its long-term, sustainable future.

The access road runs between the studio lot that has been described as a series of fenced-off aircraft hangars in some overcrowded street, and St Mary's Reservoir on the right.

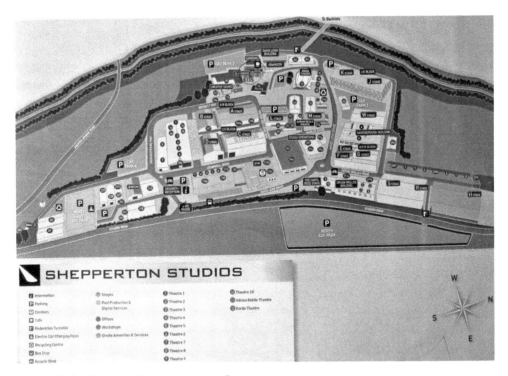

Map of the buildings within the perimeter fencing.

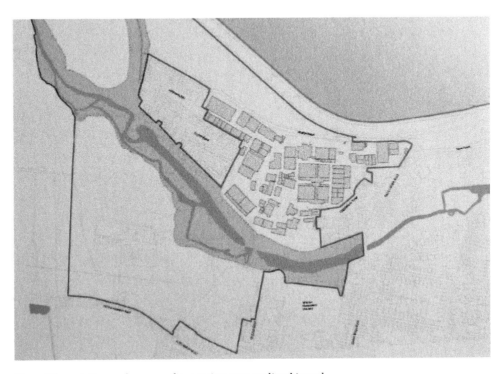

Plan of the existing and proposed extension area outlined in red.

While the future of Shepperton studios was being decided, filming went on as usual with new feature films like *Judy* starring Renee Zellweger as the iconic performer and featuring some of Judy Garland's best-known songs. But in February 2019 the £500 million development moved on to the next phase when outline planning permission for the expansion set to quadruple the plot was narrowly passed by the planning committee at Spelthorne Borough Council – seven votes to six.

Gaining planning permission for a £500 million expansion at Shepperton will make it the second-largest studio in the world, and as such has attracted a major deal with Netflix, the American media services provider and production company. 'Netflix's decision is a real vote of confidence in the UK film and TV industry,' said Paul Golding, the chief executive of Shepperton's parent Pinewood. 'It's all about confidence in the UK as a location for top quality productions, something that Shepperton can always be proud to provide.'

In response, Ted Sarandos, the chief content officer for Netflix, said: 'the studio has been synonymous with world class film for nearly a century and we are incredibly proud to be part of that heritage.'

The marriage of Shepperton studios and Netflix brings together the best of the old and the best of the new, something that the little riverside town of Shepperton can be justly proud of.

DID YOU KNOW
If you'd like to learn more about Shepperton, why not join the Sunbury and Shepperton Local History Group that meets monthly at Halliford School, Russel Road.

Cut – the end.